The Courtauld
Highlights from the Gallery

Scala Arts & Heritage Publishers,
London and New York

This edition © Scala Arts & Heritage Publishers Ltd, 2021
Text © The Courtauld, 2021
First published in 2021 by Scala Arts & Heritage Publishers Ltd
Registered address:
27 Old Gloucester Street
London WC1N 3AX

In association with
The Courtauld Institute of Art
Somerset House
Strand
London WC2R 0RN
www.courtauld.ac.uk

Project manager and copy editor: Claire Young
Designer: Joe Ewart
Printed and bound in Italy
10 9 8 7 6 5 4 3 2 1
ISBN 978-1-78551-405-0

Contents

Foreword

The Courtauld Institute of Art is a unique institution – with no exact parallel nationally or internationally. Founded nearly 90 years ago as an institute of the University of London, The Courtauld has gone from strength to strength. Initially set up in Home House, the former residence of Samuel and Elizabeth Courtauld, The Courtauld was the beneficiary of many of the great masterpieces that they had collected in the 1920s. With their passionate purpose, it is not surprising that The Courtauld has continued to attract art collections of great significance by bequest and gift.

From 1958 onwards, the collection was open to the public, but it remained a delight of the few rather than an asset for the many. The Courtauld's move to Somerset House in 1989 not only provided the institution with a long-term home, but also brought the collection more into the public domain. It played a critical role too in triggering the transformation of Somerset House into the cultural and educational centre that it has become. In 2002, The Courtauld became a self-governing college of the University of London, the smallest of the distinguished group of world-class institutions that makes up the federation of the University. Each year it attracts nearly 600 students from all over the world to study art history, conservation of paintings and curating for their BA, MA and PhD degrees and diplomas. The range of its teaching, research and programming is expanding, becoming more global, and embracing the arts of Asia and Africa and their diasporas in addition to its longstanding engagement with European traditions. It continues to flourish as one of the most significant centres for the study of art history and conservation in the world. Its distinguished alumni are leaders in all dimensions of the art world internationally.

The founders of The Courtauld believed profoundly in rigorous scholarship, but they were also fundamentally humane in their wish that works of art and the scholarship required for their best understanding be readily accessible to the widest audience possible. Today we embrace the same ideals. With the support of many individuals, trusts and foundations, and the National Lottery Heritage Fund, we have recently completed the ambitious renovation of the Gallery. We are very grateful indeed to them all as we look ahead with excitement to the next stage in the life of The Courtauld as it approaches its centenary in 2032.

Deborah Swallow
Märit Rausing Director,
Courtauld Institute of Art

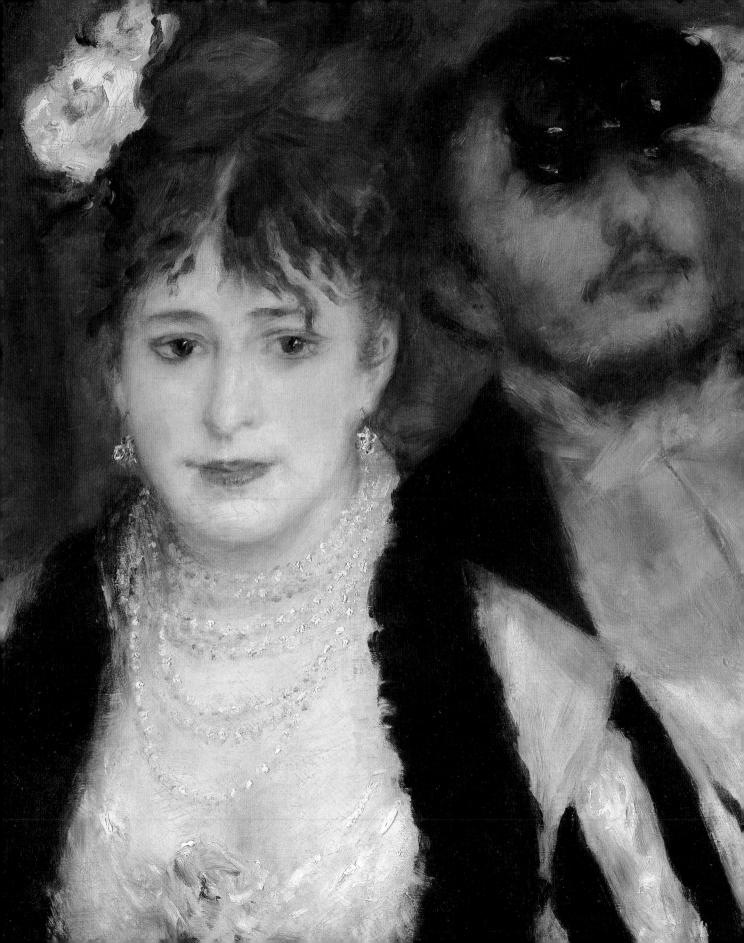

The Courtauld Gallery and its Collection

Ernst Vegelin van Claerbergen
A & F Petitgas Head of the Courtauld Gallery

This book marks the reopening of the Courtauld Gallery after the completion of a far-reaching programme of modernisation and renewal. The Gallery derives its unique character not only from its extraordinary collection and inspirational setting, but also from its identity as part of the Courtauld Institute of Art, the world's leading centre for the teaching and research of art history. This short introduction traces the evolution of the collection since 1932, when the textile magnate and philanthropist Samuel Courtauld (1876–1947) and others founded this unique institution with the mission to transform the role of art in society [1].

The collection comprises some 550 paintings, 7,000 drawings, 26,000 prints and 550 items of decorative art and sculpture, concentrating broadly on European art – although with several important exceptions. It has evolved principally through a series of magnificent complementary individual

gifts and bequests, a precedent that Courtauld set with the donation of his Impressionist masterpieces.

Samuel Courtauld's ancestors were Huguenots (French Protestants) who fled religious persecution in the late seventeenth century and settled in London. They prospered as silversmiths before moving into the booming textile business, where they specialised in the Victorian fashion for silk mourning attire. At the beginning of the twentieth century, the company acquired the patents for a revolutionary new artificial fabric called viscose, or rayon. Within a few decades, Courtaulds Ltd was transformed from a successful family-run manufacturing business into one of the largest textiles and chemical companies in the world. It had research and production facilities across the United Kingdom [2], as well as a vastly profitable American subsidiary and numerous international

[1] Samuel Courtauld (1876–1947), 1920s

[2] Courtaulds Ltd factory in Coventry, 1928

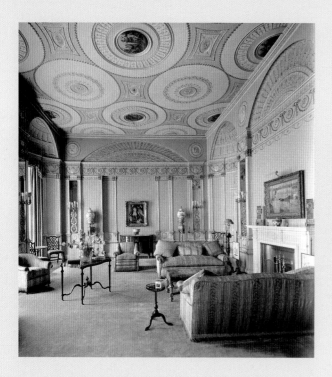

partnerships. Courtauld was chairman of the company from 1921 to 1946.

In 1901, Samuel Courtauld married Elizabeth Kelsey (1875–1931) and it was she who, in 1922, bought the couple's first modern paintings. By the end of that decade, they had formed one of the greatest private collections of Impressionist and Post-Impressionist art ever assembled, comprised of over 60 paintings and 30 drawings, as well as sculptures and prints. The collection featured seminal works by all the major artists associated with those movements, including Renoir's *La Loge*, purchased in 1925 (pp. 74–75), Manet's *A Bar at the Folies-Bergère*, acquired the following year for $110,000 (pp. 78–79), and Van Gogh's *Self-Portrait with Bandaged Ear* (pp. 100–01). Courtauld was particularly devoted to the work of Paul Cézanne, assembling a group of 11 paintings by the artist, as well as important watercolours.

Much of Samuel Courtauld's collection was formed during the 1920s. Impressionism as a movement was some 50 years old, but was still regarded with hostility by the insular British art establishment. Courtauld saw things differently: he considered Impressionism's interest in modern themes and its emphasis on direct individual experience as a powerful renewal of the great tradition of Western painting. The Courtaulds installed the collection in Home House, their magnificent London townhouse at 20 Portman Square, near Oxford Street. Whilst capturing its grandeur, photographs of the interior also reveal how Courtauld lived with his paintings daily as a source of joy and fulfilment [3].

Samuel Courtauld's championing of Impressionism forever changed public taste in the United Kingdom, but should be understood in the context of a higher purpose. Courtauld had a radical vision for the renewal of society and the role of art. Although by nature a private man, he vigorously promoted progressive views on education, welfare, social mobility and labour relations. He saw art as a powerful antidote to the degrading effects of industrial capitalism and consumerism. In parallel to Elizabeth, who used her wealth to make the best classical music available to new audiences, Samuel wanted the art that he loved to be widely enjoyed. In addition to forming his own collection, in 1923 he established the Courtauld Fund which, over the following years and under his direction, acquired many of the greatest Impressionist and Post-Impressionist paintings now in the National Gallery, London. Similarly, he determined that his private collection should be donated for public benefit, and this, alongside education and scholarship, would become one of the founding principles of the Courtauld Institute of Art.

The idea for a higher-education institution with its own gallery, dedicated to the history of art, originated with Arthur Lee, Viscount Lee of Fareham (1868–1947). In 1917, he and his cherished American wife, Ruth Moore (1869–1966) [4], donated Chequers, their estate in Buckinghamshire, to the nation for use as a country retreat by the serving prime minister. Lee retired from a distinguished political career

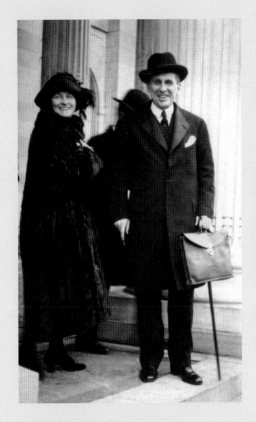

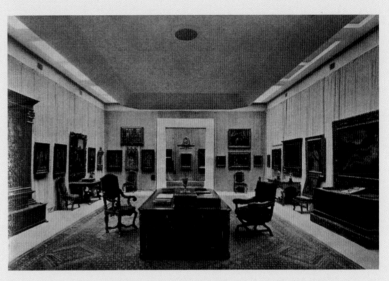

[4] Arthur and Ruth Lee in 1921, in a photograph taken when Lee was First Lord of the Admiralty

[5] The interior of Lord and Lady Lee's gallery at Old Quarries in Avening, Gloucestershire

soon afterwards. He devoted the remainder of his life to art, with fierce and sometimes irascible independence. He was an intrepid and opportunistic collector, relishing the challenge of acquisitions and re-attributions, and emphatically asserting the place of the private collector in the face of a growing community of self-appointed experts – whose credentials and motivations he regarded with suspicion. Lee's approach resulted in some singular successes, including the acquisition of Botticelli's *Trinity* altarpiece, one of the most important paintings by the artist in the United Kingdom (pp. 36–37). Lee was exceptional for his deep interest in the practical issues of displaying works of art: he installed his collection in a much-admired private gallery, built as an annex to his home in Avening, Gloucestershire [5]. When, in 1958, the Courtauld Institute of Art developed its first dedicated gallery for the collection, the interiors were closely modelled on Lee's designs.

Lee and Courtauld were keenly aware that, whereas the United Kingdom had many of the world's finest art collections, it offered no university education in the history of art. They believed that this was essential if art was to become more than a past-time for the privileged. Another important early advocate was Courtauld's neighbour in Portman Square, the lawyer and drawings collector Sir Robert Witt (1872–1952). In developing their scheme, Lee, Courtauld and Witt were particularly inspired by the new Fogg Art Museum at Harvard University, where degree courses were taught with immediate access to original works of art, specialist libraries, study facilities and laboratories for technical examination. This integrated approach would be the template for the new Institute. Courtauld provided most of the funding, with further donations coming from Witt, John Graves of Sheffield, the dealer Joseph Duveen, Martin Conway and others. The Courtauld Institute of Art was duly established in 1932, under the aegis of the University of London.

Soon after the death of Elizabeth in 1931, Courtauld presented the nascent Institute with their residence, establishing the Home House Society (now the Samuel Courtauld Trust) in her

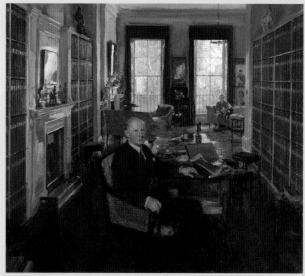

memory and endowing it with the majority of his art collection. The doors of the Courtauld Institute of Art opened in October 1932, offering its students a rich curriculum in Western art history alongside, initially, aspects of Asian art. A department for conservation and technical study was soon created. It was Courtauld's vision that the students who trained at this new institution would become teachers and lecturers, museum curators and directors, conservation specialists, writers and critics and that, in these and other roles, they would spread the understanding and enjoyment of art as part of the creation of a more just and humane society.

Although it was accessible to the public by appointment and through extensive loans to other museums and galleries, the collection itself was not yet in a position to contribute fully to Courtauld's vision. Improbably, during these early years, the Impressionist paintings that he had donated hung on the walls of the Courtauld Institute of Art's seminar rooms and other working spaces. When Lee promised his own collection of over 100 paintings, it became clear that new premises would need to be found. A solution was offered by the University of London's plan to develop its campus in the nearby Bloomsbury district. A scheme was drawn up for a building in Woburn Square that would house a dedicated gallery alongside facilities for teaching and research. The plans also included the Warburg

Institute, which, in 1933, Lee and Courtauld had done so much to rescue from Hamburg, where it was critically threatened by the rise of the Nazi regime. In fact, this architectural scheme was only partially executed. Although the Gallery moved to its new purpose-built space in Woburn Square in 1958 [6], the core of the Courtauld Institute of Art remained at Home House.

By this time, the Gallery had grown in an important new direction. In 1952, Witt bequeathed his expansive collection of 3,000 drawings along with his celebrated photographic reference library [7]. Witt's gift established the collection of works on paper, which has since developed into one of the Gallery's greatest strengths. Roger Fry (1866-1934), the influential critic, painter and champion of modern French art, was another early supporter of the Courtauld Institute of Art. His eclectic collection came to the Gallery soon after his death and was later supplemented by his daughter, Pamela Diamand. As a result, the Gallery holds an important body of works by the bohemian Bloomsbury Group, as well as designs and decorative arts by the avant-garde Omega Workshops (pp. 120–21).

In 1966, the Gallery received a magnificent bequest from the Gambier-Parry family. Formed by Thomas Gambier Parry (1816–1888), and bequeathed by his grandson Mark, this remains a rare example of an important art collection to have survived largely intact from the Victorian era.

Active principally in the 1850s–60s, Gambier Parry [8] was one of a few collectors in Britain at that time who recognised the historical importance of Italian painting from the fourteenth and fifteenth centuries. Orphaned at an early age, Gambier Parry had inherited a considerable fortune, derived from the colonial British East India Company. This enabled him to purchase Highnam Court [9], an estate in Gloucestershire, and to commission a remarkable group of buildings, including the Church of the Holy Innocents, which he decorated with frescoes. At the heart of Gambier Parry's collection was a major group of gold-ground paintings by early Renaissance artists such as Lorenzo Monaco, Bernardo Daddi and Fra Angelico (pp. 20–21, 26–27). Gambier Parry also acquired decorative arts, often during extensive travels. He assembled a fine collection of Renaissance maiolica and other ceramics, a superb group of medieval and later ivories, and outstanding examples of metalwork from the Islamic world. These now form the core of the Gallery's holdings of decorative arts.

The Gambier-Parry bequest was joined a year later by the distinguished collection of British watercolours formed by William Wycliffe Spooner (1882–1967), adding further depth to the holdings of works on paper. It was followed in 1974 with the gift of 13 watercolours by J.M.W. Turner gathered by Samuel Courtauld's brother, Sir Stephen Courtauld (1883–1967) and donated by his niece Jeanne (pp. 64–65).

In 1978, the arrival of the peerless Princes Gate collection raised the Gallery to an entirely new level of public importance. The Princes Gate bequest was one of the most significant single gifts to a museum in the United Kingdom during the twentieth century. Assembled by Count Antoine Seilern (1901–1978) and named after his London address, the bequest included some 130 paintings,

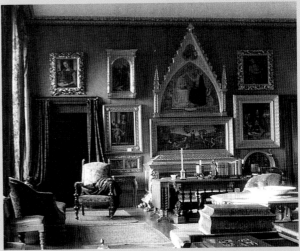

a PhD on Peter Paul Rubens at the University of Vienna, before moving to England on the eve of the Second World War. He undertook voluminous and detailed correspondence with scholars and curators, assembled an extensive reference library of books and comparative photographs, and travelled widely to study art in museums, print rooms and exhibitions across Europe. This research led to a series of meticulously compiled scholarly catalogues documenting his collection. The superlative quality of the Princes Gate collection is established by its earliest works from Southern and Northern Europe: Bernardo Daddi's exquisite portable tabernacle of 1338 and the *Entombment Triptych* of around 1425, attributed to Robert Campin (pp. 24–25). Paintings by Parmigianino and Quinten Massys, and two exceptionally rare panels by Pieter Bruegel the Elder (pp. 40, 41, 50–51), carry the collection towards the seventeenth century where a breathtaking sequence of oil sketches and major compositions by Rubens reveals Seilern's fascination with this protean artist (pp. 54, 55). The breadth of Seilern's taste is indicated by the vast *Prometheus Triptych*, commissioned from Oskar Kokoschka for a ceiling in Princes Gate (pp. 124–25).

Count Seilern's collection of drawings was in every respect the equal of his paintings and featured examples by Albrecht Dürer, Leonardo da Vinci, and Rembrandt, amongst others. Michelangelo's *The Dream* (pp. 46–47) is one of several particularly renowned individual drawings. Seilern not only collected some artists in depth but also across different media, enabling the study of their ideas and working practices in painting, drawing and printmaking.

Generous donors have continued to expand the collection in recent decades. The bequest by Dorothy Scharf (1942–2004) of 50 important

400 drawings and 270 master prints. Alongside Samuel Courtauld's great Impressionists, it is the cornerstone of the Courtauld Gallery's collection.

Count Seilern [10] was born into a privileged central-European world that would be shattered by the Second World War. His early adulthood was shaped by a love of adventure and sport: horse-racing in his native Austria, big-game hunting in the Yukon and other far-flung locations. It was an unlikely start for a man who would become the exemplar of the scholar-collector. In the 1930s, Seilern worked towards

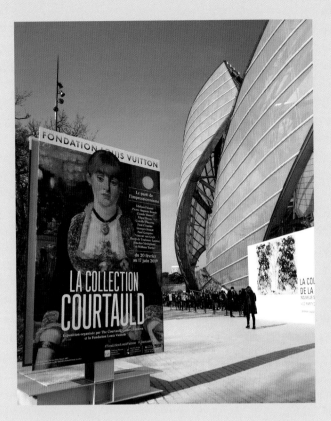

conceived for the Royal Academy of Arts and other societies of the Enlightenment (pp. 66-69). The relocation was completed by 1990, and the following years witnessed the steady growth of the Gallery's professional activities alongside the development of its collection. Importantly, in 2005, a much-admired programme of focused temporary exhibitions was established. The Gallery also began to work regularly with leading contemporary artists. Where possible, changes were made to the building to accommodate this growth and to meet the shifting expectations of museum-going audiences. Particularly successful was the development in 2015 of the Gilbert and Ildiko Butler Drawings Gallery. However, localised adaptations of the building were soon exhausted and, in late 2018, the Gallery closed for a comprehensive modernisation programme. This complex project was made possible by the National Heritage Lottery Fund and other generous supporters.

The period of temporary closure allowed the Gallery to share highlights from the collection with large international audiences, ranging from Paris [11] to Tokyo. In the United Kingdom, inspiring new partnerships were established with museums and communities in cities where Courtaulds Ltd factories once stood. At home in London, the magnificent building that the Gallery occupies has now been preserved for future generations and been made more fully accessible and welcoming for all visitors. The collection that it houses has been comprehensively redisplayed, and benefits from the new facilities created for its conservation and study. The Courtauld now looks forward with optimism to its centenary in 2032, guided, above all else, by its founding mission to serve society through the enjoyment and understanding of art.

British watercolours enhanced the Gallery's strength in this area. In 2016, Brigid Peppin's gift of a series of rare works on paper by the avant-garde artist Helen Saunders became the largest group of works by a female artist in the collection. Most recently, Linda Karshan has given an exceptional collection of drawings by modern masters in memory of her husband, Howard Karshan (1933–2017). Ranging from Wassily Kandinsky and Paul Klee to Philip Guston and Georg Baselitz, the Karshan Gift extends the collection across the span of the twentieth century, and we hope to add to this in the years to come.

With the arrival of the Princes Gate collection in 1978, it became clear that the Gallery had outgrown its home in Woburn Square. Coincidentally, the Courtauld Institute of Art's lease on Home House was due to expire, creating an opportunity to reunite the Gallery with the Institute's teaching and research activities in one location. The Courtauld's new home would be the north wing of Somerset House, designed by William Chambers (1723-1796) and one of the finest Georgian buildings in London. Suitably perhaps, this building had been

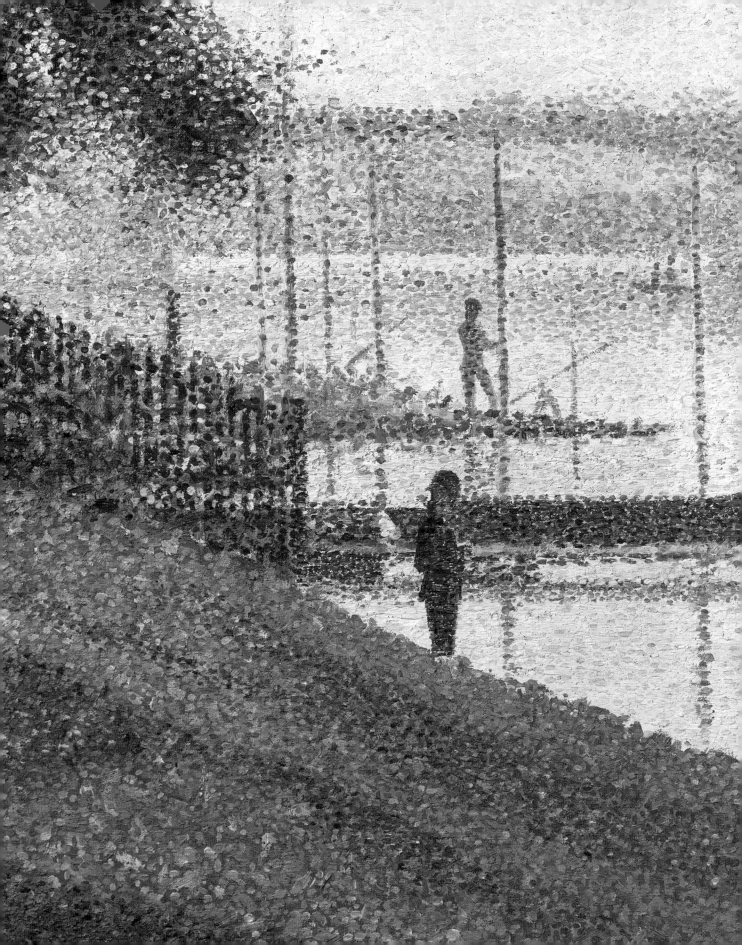

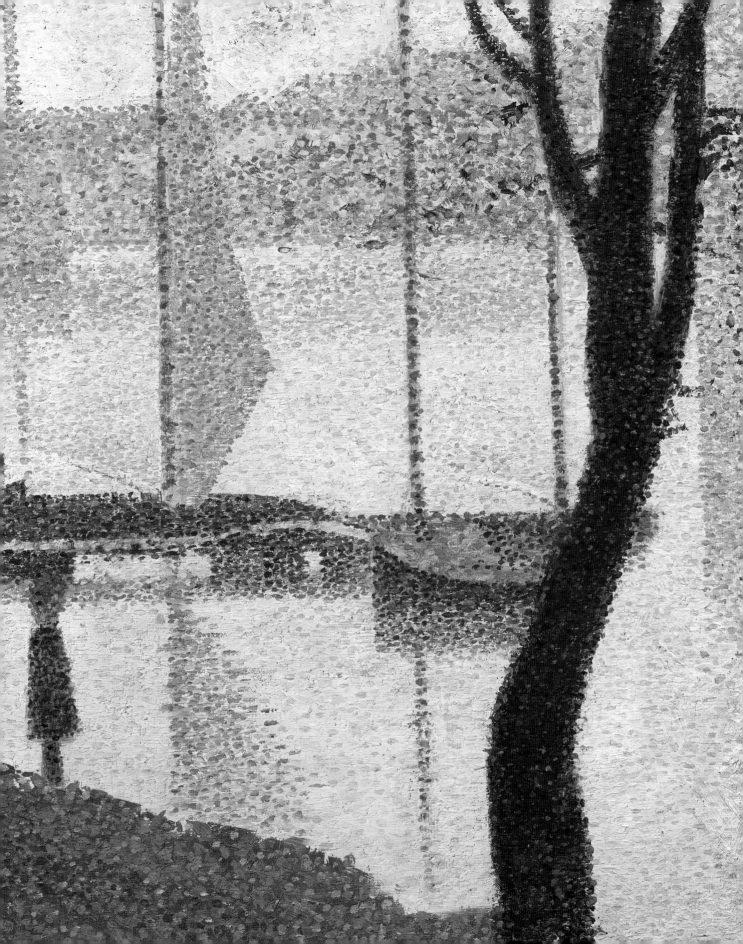

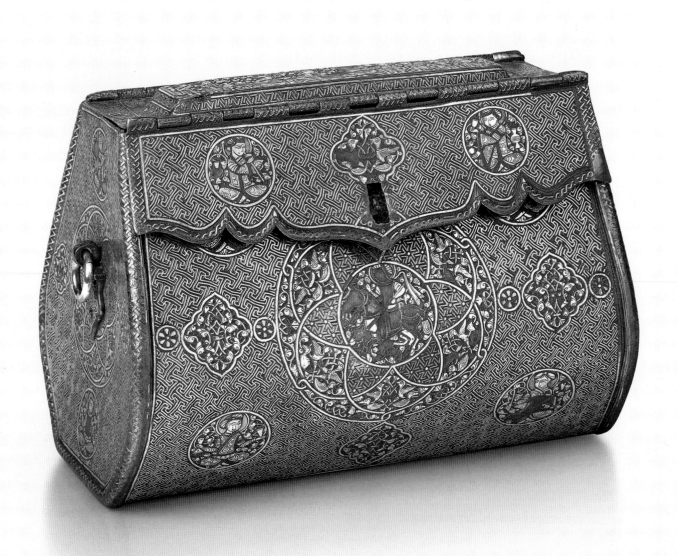

The Courtauld Bag, 1300–30
Mosul, Iraq (Ilkhanid dynasty, 1256–1353)

Hammered brass, chased and inlaid with silver and gold
15.2 × 22 × 13.5 cm
Mark Gambier-Parry bequest, 1966

The Courtauld Bag is one of the finest pieces of metalwork from the Islamic world. Roundels on the bag's body feature musicians, revellers and horsemen. The key to the bag's function is found on its lid. Here a courtly feast unfolds, framed by a band of inscriptions praising its owner (see below). Attendants in minutely patterned coats and sumptuous hats bring food and drink in luxurious vessels of the type found across Asia and the Middle East. An attendant at either end offers courtly entertainments of music and hunting. In the centre sits an enthroned female figure, probably the ruler's consort (khatun). Her personal attendant, wearing a similar bag across his chest, offers her a mirror. The loop attachments still present on the Courtauld

Bag confirm it was likewise once worn with straps. The bag's unique shape and exquisite workmanship indicate it was a prestigious commission for a high-ranking woman such as the one represented on the lid. Perhaps it was made for a noblewoman of the Ilkhanid dynasty, a branch of the Mongol Empire descended from Genghis Khan (1158–1227), whose rule centred in modern-day Iran and Iraq.

This magnificent object is part of a small but significant group of fine metalwork from the Islamic Middle East dating from 1300–1550 assembled during the Victorian period by the collector and artist Thomas Gambier Parry and bequeathed to The Courtauld by his grandson.

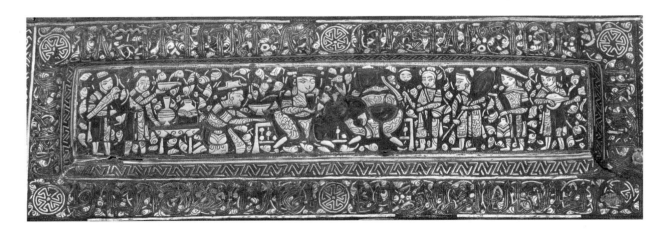

Inscriptions

العز و الاقبال و النعـ[مـ]ة و الافضال	Glory and prosperity and (God's) grace and eminence
و(ا) بلوغ الآمال و صلاح الاعمال	And fulfillment of wishes and prudence in deeds
و ا لاكرام و [ا] لاجلال	And respect and honour
و الاحسان و اجمال (كذا) [الاجمال]	And benevolence and decent act (?)
و الدولة بلا زوال	And undiminishing good-fortune
و السعادة بلا انفصال	And uninterrupted happiness
و التمام و الكمـال	And perfection and excellence
و السلام	And that is all

Bernardo Daddi (active 1312–1348)

The Crucifixion with Saints, 1348

Egg tempera and gold leaf on wood, 155.8 × 217.7 cm (max)
Mark Gambier-Parry bequest, 1966

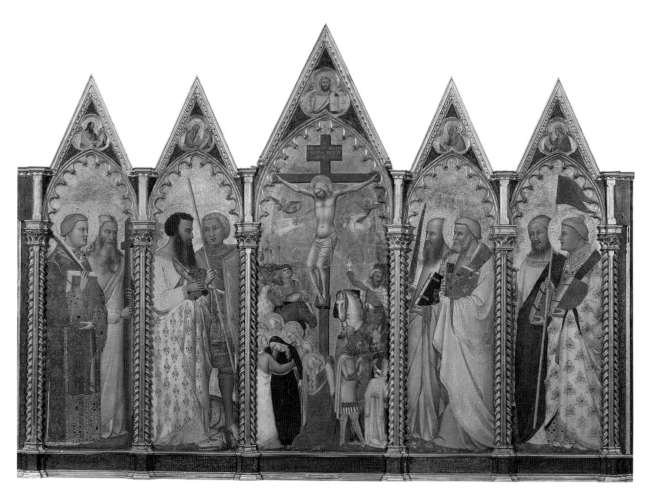

This impressive polyptych (multi-panel painting) is the main section of an altarpiece painted for the Church of San Giorgio a Ruballa, near Florence. The inscription below the central panel bears the artist's name, Bernardo Daddi, and dates the work to shortly before his death from the plague. Daddi was the leading painter in Florence at the time and the inscription is a rare and prominent assertion of his authorship.

The Crucifixion was considered a particularly appropriate theme for an altarpiece: during the celebration of Mass, it served as a visual expression of Christ's sacrifice for the redemption of humanity. The saints on either side are larger in scale, directing viewers towards this central scene.

Contemporaries praised Daddi's touching and detailed representations, such as the fainting Virgin Mary at the foot of the cross while, opposite, soldiers gamble for Christ's tunic.

Lorenzo Monaco (around 1370–1422/24)

The Coronation of the Virgin, around 1388–90

Egg tempera and gold leaf on wood, 195 × 154.7 cm (max)
Mark Gambier-Parry bequest, 1966

This imposing panel is an early independent work by a young artist named Piero di Giovanni, who had only just left the studio where he had trained. Shortly after completing this painting, he joined a monastic order and became Friar Lorenzo 'Monaco' ('monk' in Italian). He remained Florence's leading painter for many decades.

As its triangular shape suggests, the painting was made for the top of a large altarpiece, which once stood in the Church of San Gaggio in Florence. The crowning of the Virgin Mary by her son, Jesus, as she reaches Heaven was considered appropriate for this elevated position. Details such as the marble tiles and gold-embroidered cloth behind the throne would have been difficult to see by the congregation. However, the altarpiece was intended as much for God's viewing as for the churchgoers'. Mary's robe was originally painted a bold red but has faded to white over time.

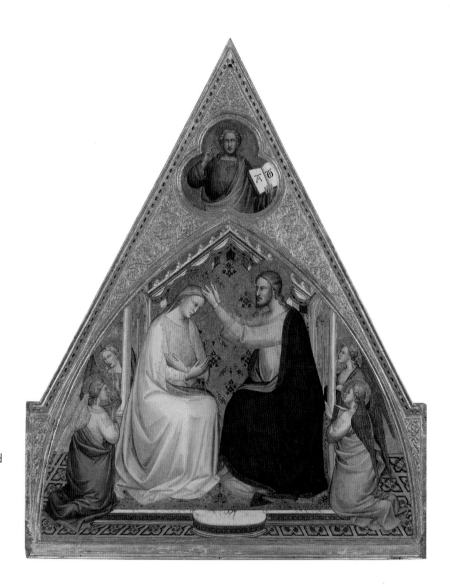

Diptych with Scenes of the Passion of Christ, around 1350–75
Paris, France

Carved ivory, 19.2 × 21 cm
Mark Gambier-Parry bequest, 1966

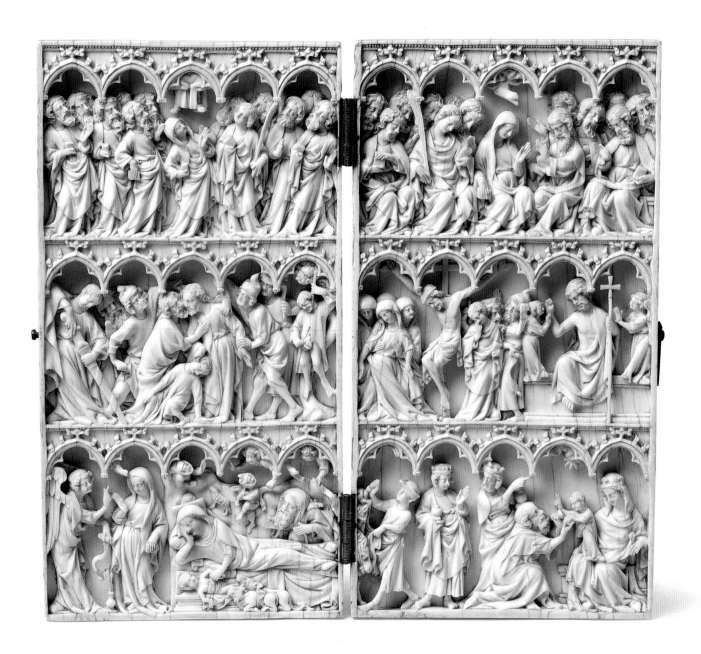

Triptych with the Virgin and Child, around 1325–50
Northern France or Italy

Carved ivory with traces of pigment and gold
17.6 × 12.7 cm
Mark Gambier-Parry bequest, 1966

Ivory, taken from African elephant tusks, was prized in medieval Europe as a precious material and traded across vast distances. The purity and lustrousness of its surface was considered ideal for the carving of Christian subjects. Details were often highlighted in colour and gold leaf. Trade in ivory is now considered unethical and banned internationally.

During the medieval period, Paris was the most important production centre for carved ivory, with workshops specialising in religious as well as secular objects. Exported widely, Parisian ivories helped disseminate the elegant Gothic style across Europe. Diptychs, two panels hinged together, and triptychs, consisting of three panels, were made for prayer in the home and for private meditation on the life of Christ. Portable and intimate objects, they could be opened and closed like a book.

The superbly carved diptych on the opposite page belongs to a group of ivories illustrating the Passion (Death and Resurrection) of Christ, which are among the most impressive ivories to have survived from this period. The narrative begins at the bottom with the Annunciation, Nativity and Adoration of the Magi (wise men or kings). The Arrest, Death of Judas, Crucifixion and Resurrection (middle tier) are followed by the Ascension and the Descent of the Holy Spirit (in the form of an eagle) at the top.

The triptych on the right shows in its central panel the Virgin Mary and Christ Child. On either side are scenes from Christ's birth. Above, God the Father is flanked by angels. Originally, Mary likely held a carved flower. At some point, a delicate stalk was painted with gold over a crack in the ivory.

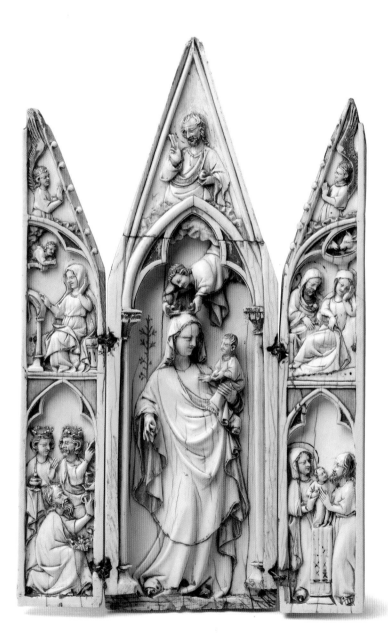

Attributed to Robert Campin (1378/9–1444)

The Entombment, known as 'The Seilern Triptych', around 1425

Oil paint and gold leaf on wood, 65.2 × 107.2 cm (max)
Princes Gate bequest, 1978

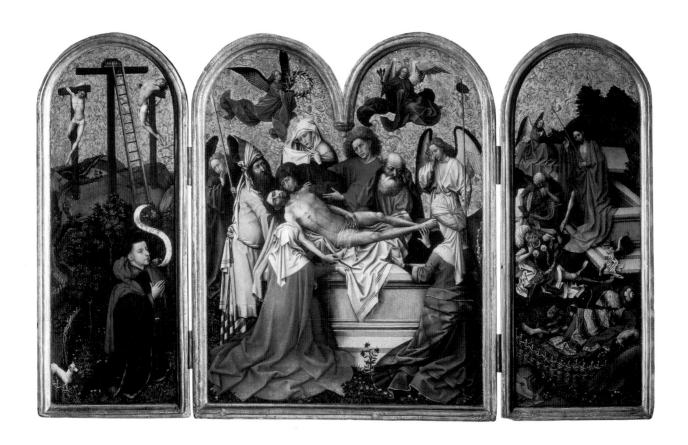

This three-panel work (triptych) is one of the finest examples of Northern Renaissance painting. In addition to a careful design and meticulous execution, it is particularly remarkable for its exquisite details, drawing viewers into these poignant scenes.

The central panel depicts Christ's burial, shortly after his body is taken down from the cross (seen in the left wing, where the two thieves executed with him remain). Christ is lowered into a stone tomb while four angels carry instruments associated with his suffering during the Crucifixion: the nails that were driven through his hands and feet, the crown of thorns placed on his head, the vinegar-soaked sponge Roman soldiers gave him to drink and the lance that pierced his side. The right wing depicts Christ's triumphant Resurrection three days later, as he emerges from the tomb while the soldiers guarding it sleep. The gold background across the entire triptych is decorated with raised motifs depicting symbolic plants such as redcurrants, grapes (both representing the blood of Christ) and gourds (associated with the Resurrection).

The man kneeling in prayer in the left wing likely commissioned the triptych for private worship in his home. He has not been identified and technical study has shown that the scroll by his mouth has always been blank.

This work is an early instance of the use of oil in painting. In contrast with the traditional egg-based paint (tempera), pigments mixed with oil enabled artists to create translucent effects and precise modelling, making figures and objects more lifelike and immediate. A leading painter in Tournai (in modern-day Belgium), Robert Campin was one of the first artists to adopt it, with stunning results. The triptych has been attributed to him on stylistic grounds. It is also often called 'The Seilern Triptych' after Count Antoine Seilern, the Anglo-Austrian collector who bequeathed it to The Courtauld.

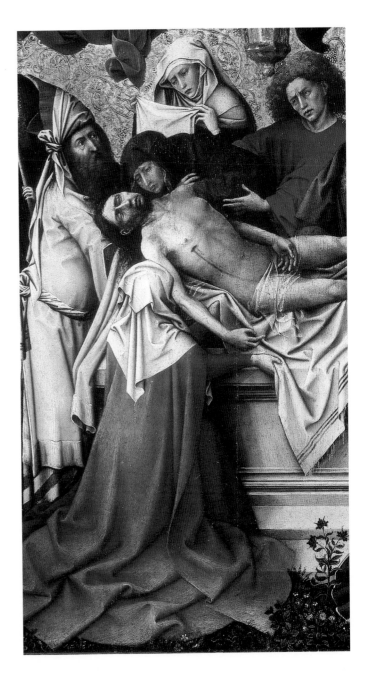

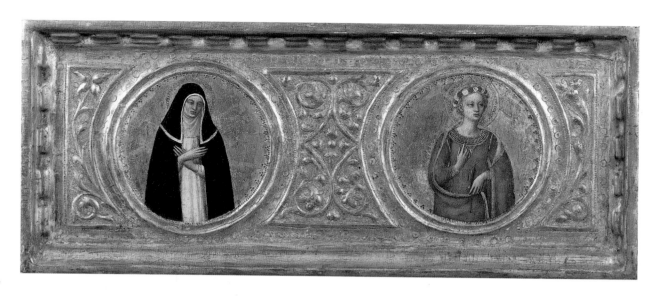

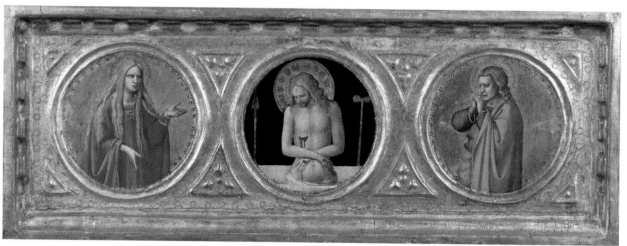

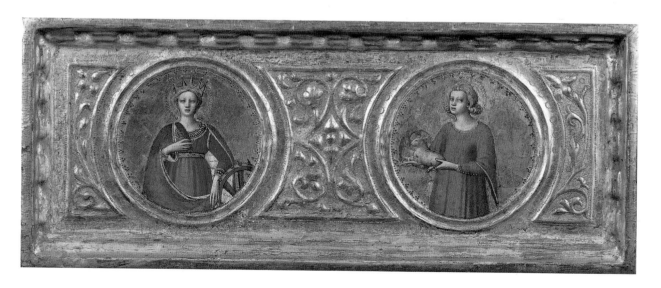

Fra Angelico (active 1417–1455)
Three predella panels, 1420s

Egg tempera and gold leaf on wood, around 21 × 51 cm (each panel)
Mark Gambier-Parry bequest, 1966

These three delicate panels representing holy figures in roundels originally formed one long horizontal sequence. They constituted the base, or *predella*, of a large altarpiece made for a convent of Dominican nuns in Florence. Its main panel (now in the Museo di San Marco, Florence) depicts the Virgin Mary and Christ Child enthroned and surrounded by saints.

The roundel with Christ against a black background is at the centre of the predella. On either side of Christ are the lance and sponge used by Roman soldiers at his Crucifixion. The other figures are saints whose relics were probably held in the convent church. From left to right, they are the Blessed Margaret of Hungary and saints Cecilia, Mary Magdalen, John the Evangelist, Catherine of Alexandria and Agnes. Despite their small scale, each one is incredibly expressive.

Born Guido di Pietro, the artist was himself a Dominican friar. He was given the name 'Fra Angelico' (Angelic Friar) after his death in honour of his devotion and the refinement of his paintings.

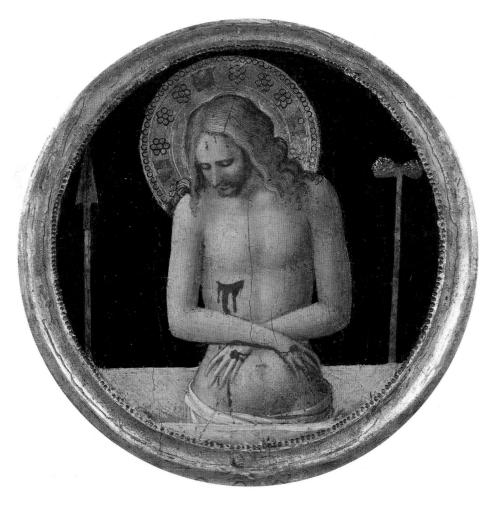

Francesco di Stefano, called Pesellino (1422–1457)
The Annunciation, around 1450–55

Egg tempera on wood, around 20.3 × 14.4 cm (each panel)
Mark Gambier-Parry bequest, 1966

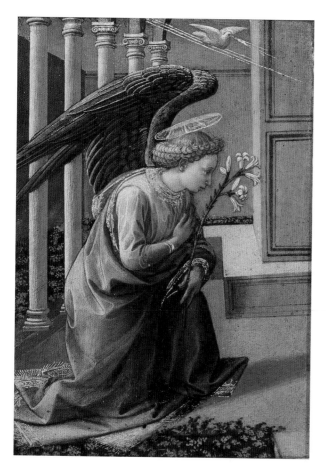 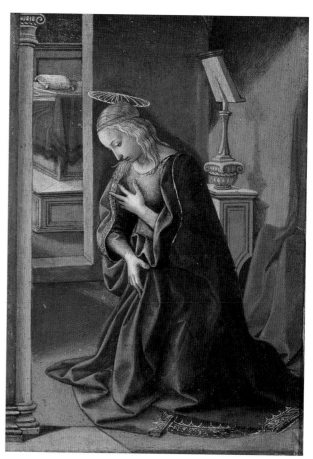

Working in Florence, Pesellino specialised in small-scale pictures for private devotion. The Annunciation was a common theme for such works. The angel Gabriel appears to the Virgin Mary outside her chamber, telling her she will soon give birth to the son of God. The restrained treatment of the subject matter encouraged contemplation on the meaning of Christ's arrival on earth, bringing believers hope for their salvation.

This two-part painting (diptych) is one of the artist's most exquisite works. Pesellino was admired for his precise style and the high quality of the materials he used. Mary's blue robe, for example, is painted with fine ultramarine, an expensive pigment made from the semi-precious stone lapis lazuli, imported from Afghanistan. The rich colours and detailed depiction draw the viewer in, creating a sense of intimacy and heightened emotion.

Leonardo da Vinci (1452–1519)
Studies for Saint Mary Magdalene, around 1480–82

Pen and brown ink on laid paper, 13.8 × 8 cm
Princes Gate bequest, 1978

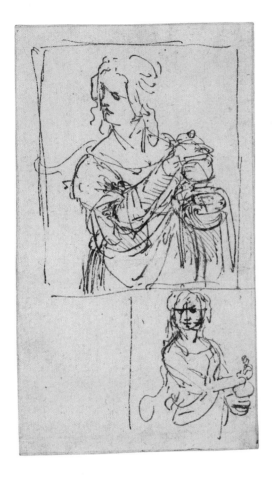

These rapid and lively pen-and-ink sketches are studies for the figure of Mary Magdalen, one of Christ's followers. They show Leonardo da Vinci exploring alternative ideas for the arrangement of this single figure. The artist began by drawing the larger version, later adding the smaller, more summary drawing below. In the first composition, the figure is shown looking away from the jar that she has just opened, implying that she has been interrupted and is turning to look at something. The jar she holds refers to the biblical episode in which Mary Magdalen anoints Christ's feet. In the smaller sketch, the artist first drew the saint looking down at the jar in her hands, then rotated her gaze to direct it towards the viewer. Although no related paintings by Leonardo have survived, the composition was later used by his pupils.

The Morelli-Nerli Chests

Biagio di Antonio (1446–1516), **Jacopo del Sellaio** (1441–1493), and **Zanobi di Domenico** (active 1464–1474)

Egg tempera, oil paint and gold leaf on wood
Each 205.5 × 193 cm (overall)
Viscount Lee of Fareham bequest, 1947

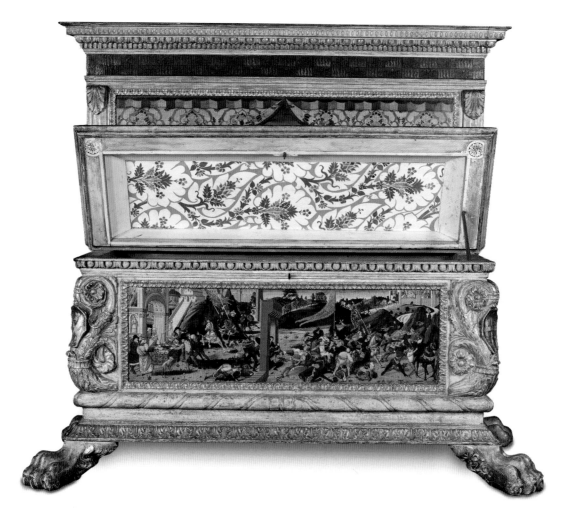

Weddings have traditionally been occasions for flamboyant spending. In elite Florentine society, wealthy husbands-to-be commissioned pairs of sumptuously decorated marriage chests, known as *cassoni*. They were paraded in the streets from the bride's family residence to her new home. Containing her dowry of linen and fine clothing, *cassoni* were displayed in the home's most important and lavishly furnished room, the husband's chamber, called the *camera*.

This pair of *cassoni* celebrates the marriage of a wealthy merchant, Lorenzo Morelli, to an aristocratic woman, Vaggia Nerli, in 1472. The families' coats of arms are displayed on the corners of each chest. This pair are a unique survival, with their original back panels, displayed on the wall above. They are decorated with small scenes framed by curtains, imitating richly patterned silk. A luxury import from the Islamic Mediterranean, such fabrics are also a reminder of the chests' function and contents.

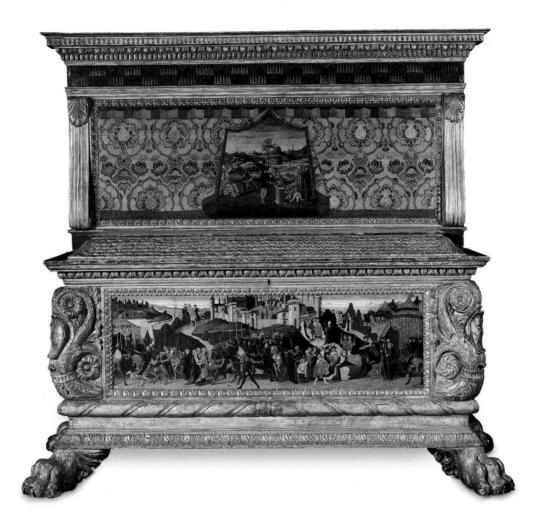

These chests were the most expensive items of furniture bought by Morelli for his palatial new home and are illustrated with tales of patriotism and moral courage from ancient Roman history. The scenes were selected by Morelli in discussion with the artists and took months to plan. Such stories, which reflect the ideals of elite Florentine society, were intended to guide and inspire the young couple and their future children.

The hero of the *cassoni* is Marcus Furius Camillus – a Roman soldier and statesman known for his bravery and fairness. On the Morelli chest (left), he chases the Gauls from Rome. On the Nerli chest (right), Camillus refuses the help of a wicked schoolmaster who offers him his pupils as hostages. The panels on the walls above show further acts of selfless heroism. On the sides of both chests are seated female figures representing the virtues of justice, fortitude, temperance and prudence.

Andrea Mantegna (around 1431–1506)
The Flagellation, with paved floor, 1465–70

Engraving, 44.2 × 34.3 cm (sheet)
Princes Gate bequest, 1978

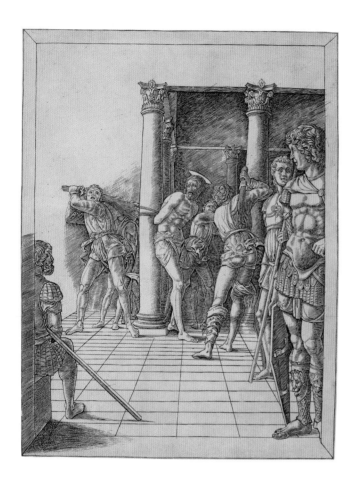

This powerful engraving depicts the tortured Christ as vulnerable and afraid, recoiling as his tormentors scourge him. One of the first Italian artists to embrace printmaking, Andrea Mantegna was attracted to its potential for creating original compositions that could disseminate his work to a wider audience. A surviving preparatory drawing for the figure of Christ, also in The Courtauld's collection, demonstrates that he devised the composition himself. As was customary, one or more members of his workshop then executed the engraving. For unknown reasons, however, the print was never finished. The sculptural quality of the bodies is achieved by modelling them with light and shade, using a range of parallel lines. Mantegna's approach to the human figure influenced other artists long after his death; this impression of the print was once owned by the Pre-Raphaelite painter Edward Burne-Jones (1833–1898), whose art was deeply indebted to Mantegna.

Albrecht Dürer (1471–1528)
A Wise Virgin (recto)
Studies of the Artist's Left Leg (verso), 1493

Pen and brown ink on laid paper, 29.1 × 20.2 cm
Princes Gate bequest, 1978

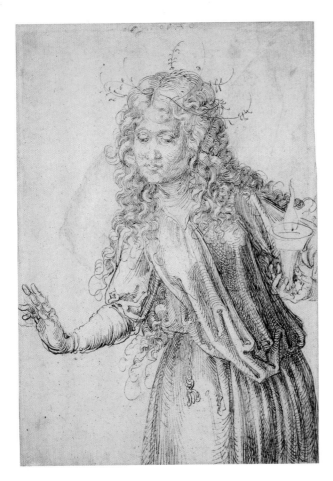 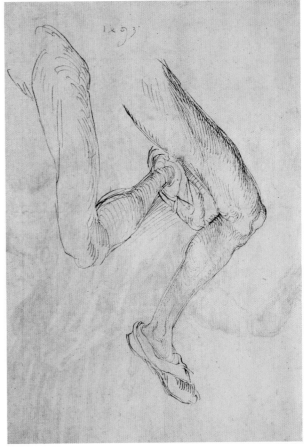

Albrecht Dürer executed this richly detailed drawing at the age of 22, while travelling through central Europe's Upper Rhine region to complete his artistic training. On one side of the sheet, he drew a female figure holding a burning oil lamp; she represents one of the Wise Virgins waiting for the bridegroom in the biblical parable of the Wise and Foolish Virgins.

Turning the paper over and rotating it, the artist sketched his own left leg from two slightly different viewpoints, adding the date 1493. The rapidly sketched lines in this drawing are direct and informal. By contrast, the carefully depicted folds of the Virgin's tunic, as well as her abundant curls, show Dürer taking a more elaborate approach, inspired by the precisely defined lines of contemporary engravings and woodcuts, which influenced his early drawing style.

Box with cover, 15th–16th century
Mahmud-al-kurdi (Master Mahmud the Kurd)
Northwestern Iran or Turkey

Hammered brass, chased and inlaid with silver and black infill
7.6 × 15.8 (diam.) cm
Mark Gambier-Parry bequest, 1966

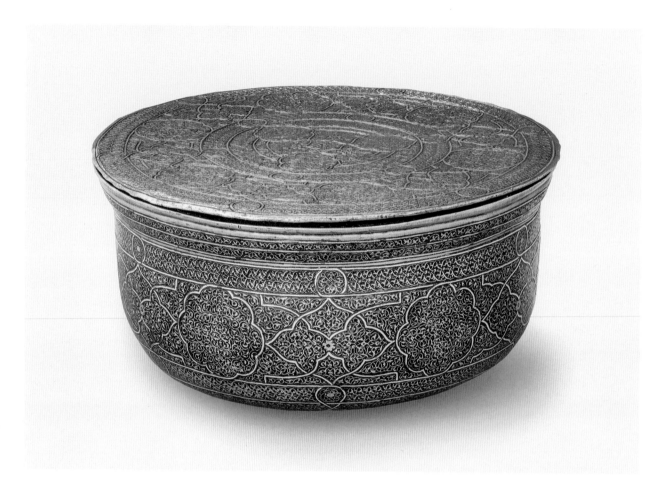

Luxury goods produced in the sixteenth century reflect intense cultural and artistic exchanges between craftsmen across the Mediterranean. In Cairo, Venice, Damascus, Florence, Valencia and Istanbul, exquisite objects were created for international markets that prized original design and superb craftsmanship. Venice was the main European trading partner of the most powerful rulers of the Islamic Mediterranean, such as the Mamluk sultans in Syria and Egypt. Master craftsmen like Zayn al-Din and Mahmud al-Kurdi responded to the tastes of European clients by adapting the calligraphic and geometrical ornamentation of Islamic metalwork into purely decorative patterning, as seen in these two magnificent examples.

Bowl-shaped boxes with matching airtight covers are rare in Islamic metalwork but were popular export ware from Mamluk Egypt and Syria. This box is signed by Mahmud al-Kurdi, whose name appears on many pieces of export metalwork. Unique among his signed boxes, it bears his name (on the rim) in both Arabic and Roman script. The latter is a transliteration of the Arabic text and reads 'the work of the master Mahmud'.

Bucket, around 1475–1500
Attributed to Zayn al-Din
Northwestern Iran, Turkey, Egypt or Syria

Hammered brass, chased and inlaid with silver
11 × 23.1 × 22.7 (diam.) cm
Mark Gambier-Parry bequest, 1966

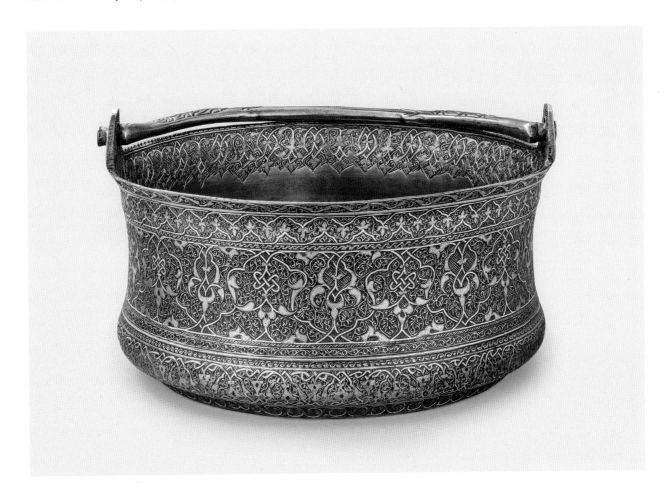

This bucket is attributed to the master metalworker Zayn al-Din. Buckets attributed to him feature a complex pattern made up of interlacing knots against an engraved background of cross-hatching and arabesques. While this one does not bear a signature, it is close to a bucket signed by Zayn al-Din in the Victoria and Albert Museum, London. The swing handle in the form of confronted fish is common to these buckets, although this handle is likely a later replacement.

The bucket's style is reminiscent of buckets made for use in the *hammam*, or bath house. Its richly inlaid surface suggests it was made for holding wine and could have been used in the *hammam*'s social spaces. The superb decoration on the underside – a sign of its richness – would have been seen as the bucket was carried from guest to guest.

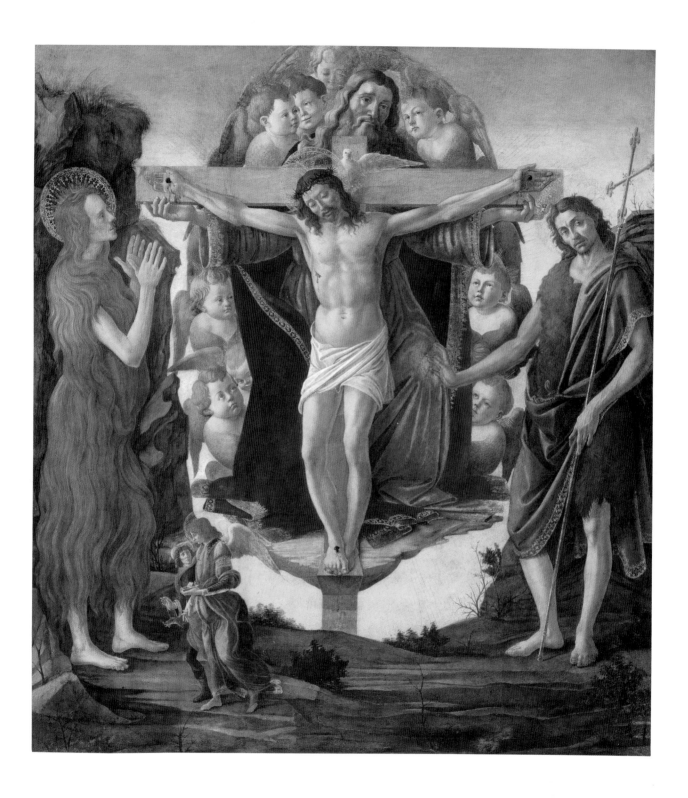

Sandro Botticelli (around 1445–1510)
The Trinity with Saints Mary Magdalen and John the Baptist, around 1491–94

Egg tempera on wood, 214 × 192.4 cm
Viscount Lee of Fareham bequest, 1947

This altarpiece is one of Sandro Botticelli's most important paintings in the United Kingdom. A vision of the Trinity dominates the work: God the Father sits on a throne surrounded by angels and holds the cross bearing his crucified son. The dove of the Holy Spirit hovers between them. The altarpiece has long been linked to the convent of Sant'Elisabetta delle Convertite in Florence, a community of nuns who welcomed repentant prostitutes. This location explains the presence, on either side of the apparition, of John the Baptist, patron saint of Florence, and Mary Magdalen, patron of the convent. The Magdalen is covered by her hair and John wears a fur garment, recalling the long periods both saints spent as hermits in the wilderness. Life for the nuns of the Convertite convent was similarly austere as they were urged to follow the example of Mary Magdalen, who abandoned a worldly life for one of penitence and devotion. The two smaller figures in the foreground are drawn from the Old Testament: Archangel Raphael guides the young Tobias on his quest to collect a debt owed to his blind father. On the way, they find a fish with healing properties able to cure the father's infirmity. The story thus echoed the convent's mission of protection and rescue.

The altarpiece is thought to have been painted around 1491–94, when work on a new chapel for the convent is documented. Recent technical study has revealed, however, that the painting's composition underwent several significant changes and its creation may have taken place over a longer period of time. For example, Tobias and Raphael were once further away behind the cross (and more in proportion to the other figures), nestled in a landscape of rolling hills that was later painted over. As was common practice in the Renaissance, many hands worked on the painting. Botticelli ran a large studio and delegated portions of larger works to assistants. In the Trinity altarpiece, it is likely that the heads of the angels were painted by members of the workshop, in contrast to the main figures that exhibit Botticelli's characteristic graceful line.

Mariotto Albertinelli (1474–1515)
The Creation and Fall of Man, 1513–14

Oil paint on wood, 56.2 × 165.5 cm
Mark Gambier-Parry bequest, 1966

This is one of three scenes commissioned by the banker Giovanmaria Benintendi, which were probably designed to be set into the decorative panelling of a room in his family palace in Florence. The background of *The Creation and Fall of Man*, with its rolling hills and wide river, recalls the countryside outside the Italian city.

The biblical story of the Creation unfolds in four lively episodes across a single landscape. On the left, God creates the animals. He then gives life to Adam and shapes Eve from one of Adam's ribs. On the right, a serpent with a human face tempts them to taste the fruit of the Tree of Knowledge, which God has forbidden them to touch. This will lead to their expulsion from the Garden of Eden, represented on one of the other panels.

Dish with one of the Magi, around 1520–40
Deruta, Italy, probably painted by Nicola Francioli
(active 1513–1565)

Tin-glazed earthenware painted with lustre, 41 cm (diam.)
Mark Gambier-Parry bequest, 1966

Lustred ceramics were a must-have luxury item for the fashionable Renaissance home. Lustre is made when a glazed and fired ceramic is painted with metal oxide pigments and fired again at low temperature with restricted air supply. This process results in a metallic film that shimmers beautifully in candlelight.

The technique of lustre originated in Iraq and Egypt and was brought to Spain by Arab potters in the twelfth century. Spain produced and exported large quantities of these coveted wares across Europe. Around 1500, specialist centres of lustred pottery were established in Deruta and Gubbio, two small towns in the central Italian region of Umbria. This superb dish shows the close ties between painting and pottery in Umbria. The image is based on a figure from a painting by Pietro Perugino (about 1446–1523), the most influential artist in the region at the time.

Quinten Massys (1466–1530)
Virgin and Child with Angels, around 1500–09

Oil paint on wood, 49.1 × 33.9 cm
Princes Gate bequest, 1978

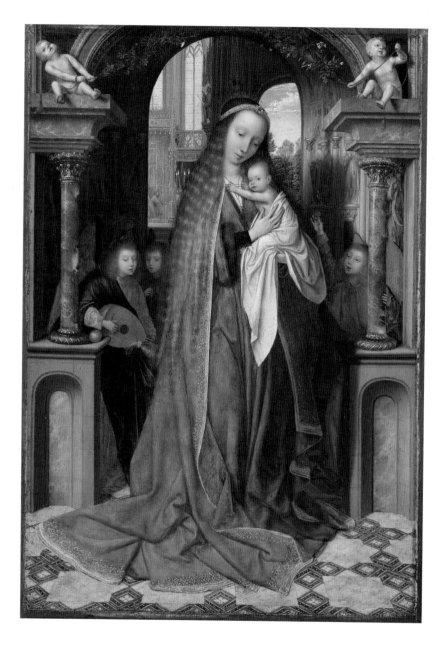

Quinten Massys was the leading painter of his generation in the Flemish city of Antwerp. Some of his works show knowledge of Italian painting, indicating that he might have travelled to Italy as an apprentice. This influence is demonstrated by the playful motif of the marble angels straining to hold a heavy garland of flowers.

However, Massys's refined rendering of texture, such as the Virgin Mary's silken hair, is distinctly northern European, as is the Gothic church architecture. Its formal setting contrasts with the tenderness between mother and child, creating a moving and powerful image made for private worship.

Parmigianino (1503–1540)
Virgin and Child, around 1527–28

Oil paint on canvas, 63.5 × 50.7 cm
Princes Gate bequest, 1978

Girolamo Francesco Maria Mazzola, nicknamed Parmigianino after his hometown of Parma in northern Italy, arrived in Rome in 1524. His paintings from that period are heavily influenced by the art he saw there. In particular, his figures combine the refinement of Raphael with the elongated limbs favoured by Michelangelo in the ceiling of the Sistine Chapel.

Several areas in this painting remain unfinished. The artist experimented with the position of the Virgin's legs but didn't conceal his previous trials; changes in the placement of her feet are still visible. The brown ground (the layer used to coat the canvas prior to painting) in the lower right-hand corner has not been painted over. In contrast, the sky and building in the background have been carefully modelled, and the architecture marked with neatly incised lines. Parmigianino might have abandoned this painting when Rome was invaded by mutinous German troops in 1527 and he was forced to flee.

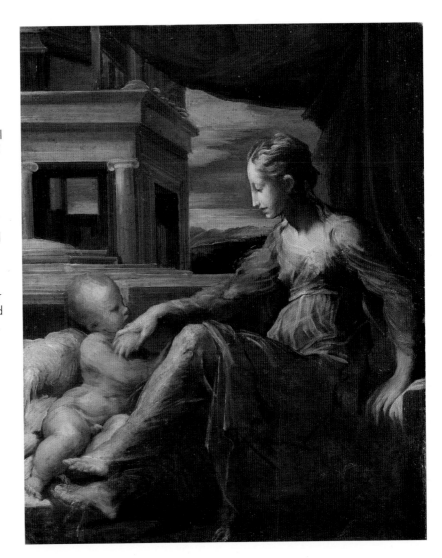

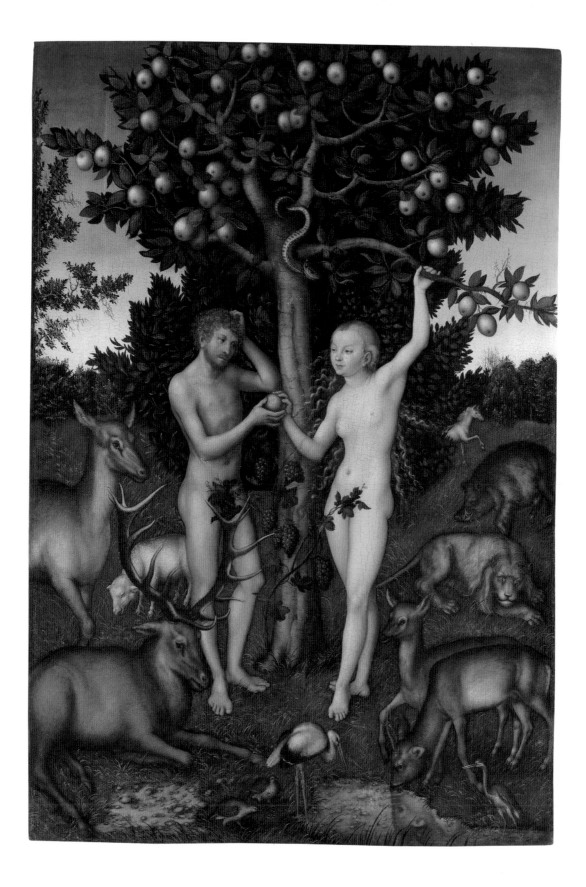

Lucas Cranach the Elder (1472–1553)

Adam and Eve, 1526

Oil paint on wood, 117.1 × 80.8 cm
Viscount Lee of Fareham bequest, 1947

Adam and Eve are depicted at the fateful moment when they disobey God and commit the first sin. The story is taken from the Bible: the Devil, in the form of a serpent coiling down the branches, encourages Eve to pick a fruit from the Tree of Knowledge, the only tree in the Garden of Eden that God has forbidden them to touch. Having bitten the fruit, Eve hands it to Adam. Although Lucas Cranach shows as him hesitant and seemingly bewildered, Adam will soon also taste it, leading to the couple's banishment. Cranach's carefully observed rendering of the peaceful animals creates a sense of serenity, soon to be lost. The placid lion and the lamb, on either side of the tree, will become natural enemies.

The artist and his workshop made over 50 versions of this subject. This painting is one of the largest and most beautiful. Its seductive depiction of nude figures in a luxuriant natural setting heightens the theme of temptation, central to this biblical story. However, the theme of redemption is also included. The vine, laden with grapes and spiralling up the tree, counters the serpent above. Wine is a traditional symbol of the blood shed by Christ, who, according to the Bible, will absolve humanity of their sins with his Crucifixion.

It is not known who commissioned this magnificent painting. Cranach worked for most of his career as painter to the court of Saxony in the city of Wittenberg (in modern-day Germany) and for members of the intellectual circles at the renowned university there.

Footed Bowl with the Crucifixion, 1550–70

Urbino, Italy, probably workshop of Orazio Fontana
(around 1510–1571), or **Antonio Patanazzi** (1515–1587)

Tin-glazed earthenware, 7.8 × 27.2 (diam.) cm
Mark Gambier-Parry bequest, 1966

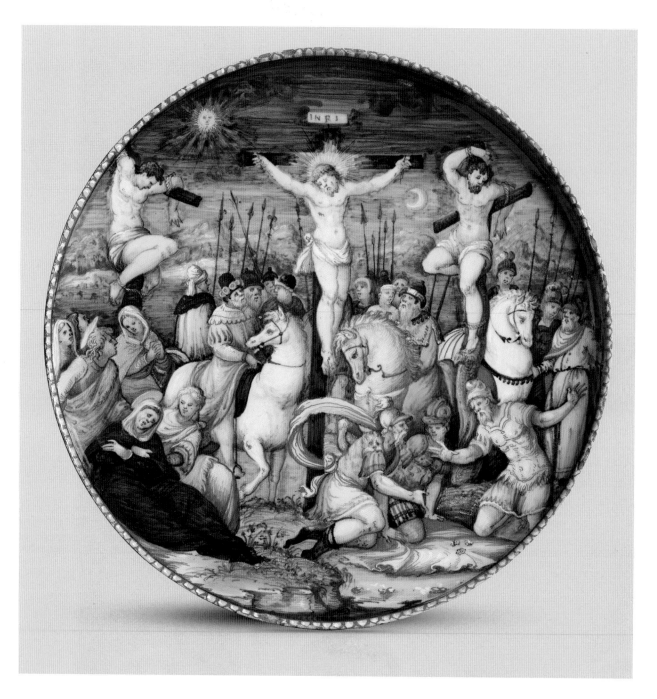

This dish is an outstanding example of the painted, tin-glazed earthenware known as maiolica that was produced in Italy during the sixteenth century. It belongs to a type of maiolica called *istoriata*, meaning painted with stories, and these were most often sourced from the Bible, ancient Roman history or Greek myths.

The scene of Christ's Crucifixion is ingeniously arranged within the circular form of the dish. Its painting is rich and complex with an exceptional variety of colour, expressive figures, beautifully rendered textures and a dramatic crowd scene. On the back, angels hover in and out of clouds, carrying symbols of Christ's Passion (Death and Resurrection). Such continuity of subject matter is rare in maiolica and might suggest that the bowl had a religious function and could have been used during Mass in a private chapel.

The former owner of this dish was Thomas Gambier Parry (1816–1880), whose collection reflects his deep spiritual engagement with Christian values. On the foot, the round sticker with the number '90' identifies the piece as having been in his collection.

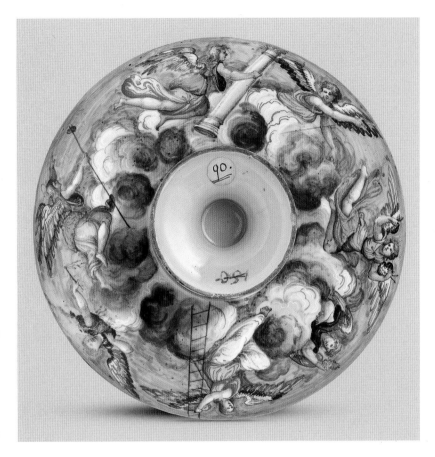

Michelangelo Buonarroti (1475–1564)

Il Sogno (The Dream), around 1533

Black chalk on laid paper, 39.8 × 28.1 cm
Princes Gate bequest, 1978

One of the finest of all Italian Renaissance drawings, *The Dream* is among The Courtauld's greatest treasures. The meaning of this enigmatic work is elusive, but its title, given just a few years after the artist's death, provides some clues.

The highly finished drawing shows a winged spirit swooping down to trumpet a message to a muscular nude male youth, who leans on a globe. Both rest on a box containing a number of masks. In the background, groups of writhing bodies appear in a cloudy haze. The main figure has been interpreted as the human mind being awakened, as if from a dream, and summoned back to virtue from the vices. In fact, all of the seven cardinal vices – except for pride – are represented by the figures in the background; from left to right, they are gluttony, lust, greed, wrath, envy and sloth. The large moneybag hovering near the youth's head symbolises greed. The masks in the box have long been interpreted as emblems of deceit and falsehood.

This drawing demonstrates Michelangelo's exceptional skills as a draughtsman and his ability to create powerful and complex compositions. The work exemplifies the artist's distinctive method of modelling flesh with virtually invisible strokes, while firmly defining the contours of the figures. The almost waxy finish of the main figures evokes the surface of sculpted stone, and, by extension, Michelangelo's extraordinary ability as a sculptor of the human form.

The Dream has been associated with a group of so-called 'presentation drawings', highly refined compositions conceived as independent works and offered by Michelangelo to his closest friends, in particular a young Roman nobleman called Tommaso de' Cavalieri. In his biography of Michelangelo (1568), the artist Giorgio Vasari praised these works as 'drawings the like of which have never been seen'. Today, they are still regarded as among the greatest single series of drawings ever made.

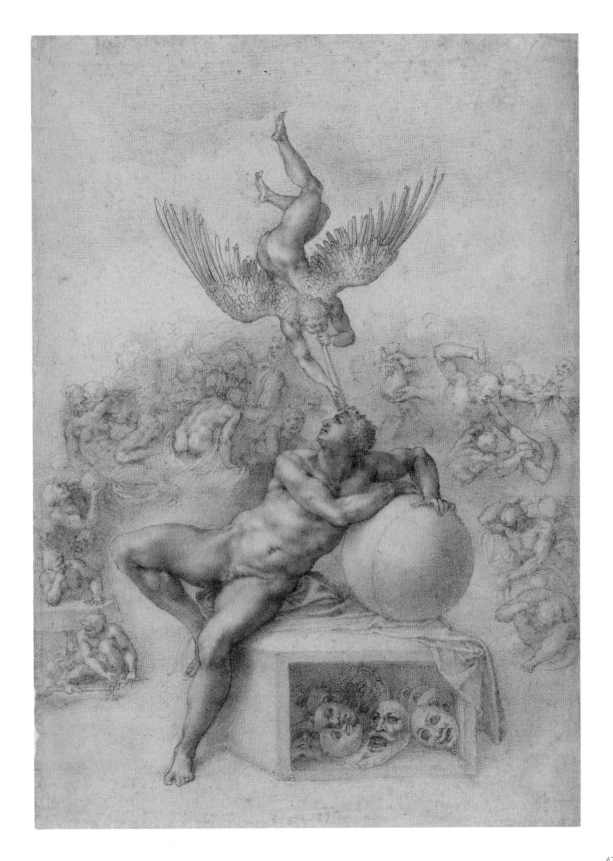

Pieter Bruegel the Elder (around 1525–1569)

Rabbit Hunt, 1560

Etching, 22.2 × 29.1 cm (plate mark)
Princes Gate bequest, 1978

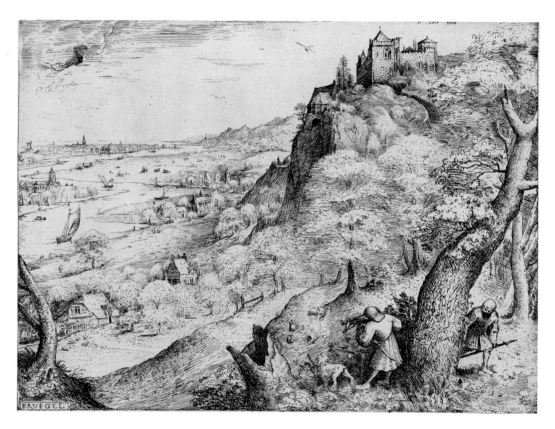

On a hillside overlooking a broad valley, a hunter accompanied by his alert dog takes aim at two rabbits, while another man carrying a spear circles the tree behind him. What appears at first to be an image of a landscape might in fact be an illustration of the proverb 'He who pursues two rabbits at once, will lose both'. However, the actions of the man with the spear are unclear and even ominous, demonstrating an ambiguity typical of Pieter Bruegel's work.

Bruegel was in great demand as a designer of prints, which were executed by skilled engravers; this rare etching is the only print he made himself. The freedom afforded by the etching technique – drawing with a pointed tool through a thin layer of ground on the printing plate – allowed him to render the scene with the remarkable naturalism found in his drawings and paintings, and to vividly evoke light and atmosphere.

Pieter Bruegel the Elder (around 1525–1569)
Landscape with the Flight into Egypt, 1563

Oil paint on wood, 37.1 × 55.6 cm
Princes Gate bequest, 1978

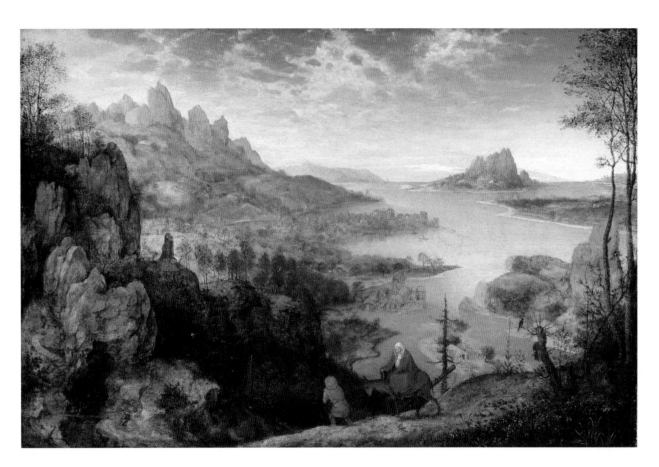

In this captivating work, Pieter Bruegel depicts the biblical story of the Virgin Mary, Joseph and their infant son Jesus travelling to Egypt to flee persecution. He sets it within an imaginary, but distinctly European, landscape. The broad valley and dramatic peaks represent the long and arduous journey ahead. Remarkably for such a small picture, Bruegel creates an epic setting packed with fine details. In the left foreground, three men cross a precipice on a rickety bridge. On the right, a small idol tumbles from its shrine on a dead tree trunk, symbolising the end of pagan worship.

Perhaps made for the French politician and collector Cardinal Antoine Perrenot de Granvelle, this painting was later owned by the artist Peter Paul Rubens (pp. 52–56).

Pieter Bruegel the Elder (around 1525–1569)

Christ and the Woman Taken in Adultery, 1565

Oil paint on wood, 24.1 × 34.4 cm
Princes Gate bequest, 1978

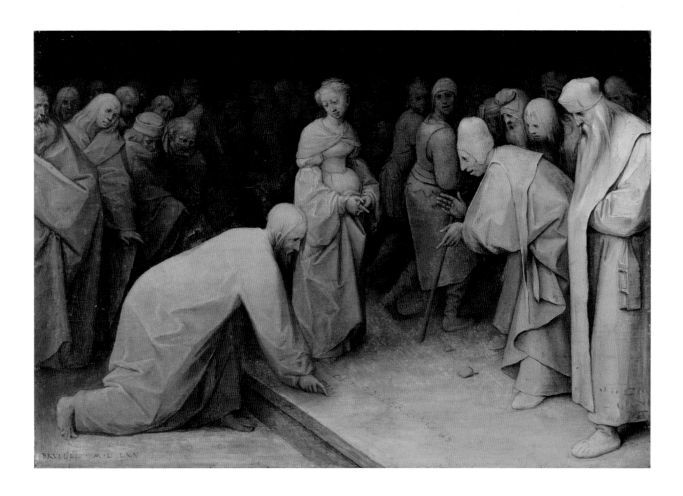

On the steps of the Temple of Jerusalem, a group of Jewish judges, including the bearded figure with a book hanging from his belt, ask for Christ's opinion on their condemnation to death by stoning of a woman accused of adultery. In response, Christ kneels and writes in the dust (here, in Dutch): 'He who is without sin, let him [cast the first stone]'. The scene can be read as a plea for tolerance at a time of political and religious upheaval in the Low Countries, where Pieter Bruegel lived.

Despite its small scale, Bruegel's representation of this episode manages to be monumental. The painter has multiplied the figures in the background to give the sense of a packed crowd. However, the protagonists and the action remain clearly defined. Bruegel painted this work using only shades of grey, a technique known as 'grisaille'. Only three such works by Bruegel survive. The limited palette shows off the artist's skill, enlivening figures with a few quick strokes of dark paint and white highlights. While works in grisaille are sometimes seen as a means to rival sculpture, the subdued colours also encourage quiet contemplation. *Christ and the Woman Taken in Adultery* – in its technique, tight composition and modelling of the figures – displays an unprecedented level of refinement in Bruegel's oeuvre.

While Bruegel's works were highly prized among his friends and collectors, he kept this painting until his death. It passed to his son Jan Brueghel the Elder who also became an artist (and is represented with his family in a painting by Peter Paul Rubens in The Courtauld, see p. 54).

Peter Paul Rubens (1577–1640)
The Descent from the Cross, 1611

Oil paint on wood, 115.2 × 76.2 cm
Viscount Lee of Fareham bequest, 1947

In 1611, Peter Paul Rubens was asked to paint a three-panel altarpiece for a side chapel in Antwerp Cathedral. *The Descent from the Cross* is an unusually large study for the central panel of this major commission. Rubens used it to define the dramatic composition and might have also presented it to his patrons and the cathedral officials for approval before embarking on the full-scale altarpiece.

The theme of the altarpiece was closely linked to its location, the chapel of the Guild of Arquebusiers (an *arquebus* is a type of long firearm and the guild members were part of the civic guard). The guild's patron saint was Christopher ('Christ-bearer' in Greek) and the biblical scenes chosen for the altarpiece feature the body of Christ being supported.

Here, Christ's lifeless body is held by his followers as he is lowered from the cross after his death. The white cloth and Christ's pale skin create a dramatic diagonal that lends unexpected dynamism to this scene of intense grief. The Virgin Mary, in dark blue, reaches out to touch her son while John the Evangelist (in red) and Mary Magdalen (kneeling in the foreground) prepare to receive Christ's body. Christ appears both incredibly vulnerable – his head hanging and his mouth open – and heroic. His strong musculature is a reminder that Rubens had recently returned to Antwerp after an almost decade-long stay in Italy, where he had studied ancient Greek and Roman statues.

The success of this commission helped launch Rubens's career and established his reputation as one of the greatest artists of his time.

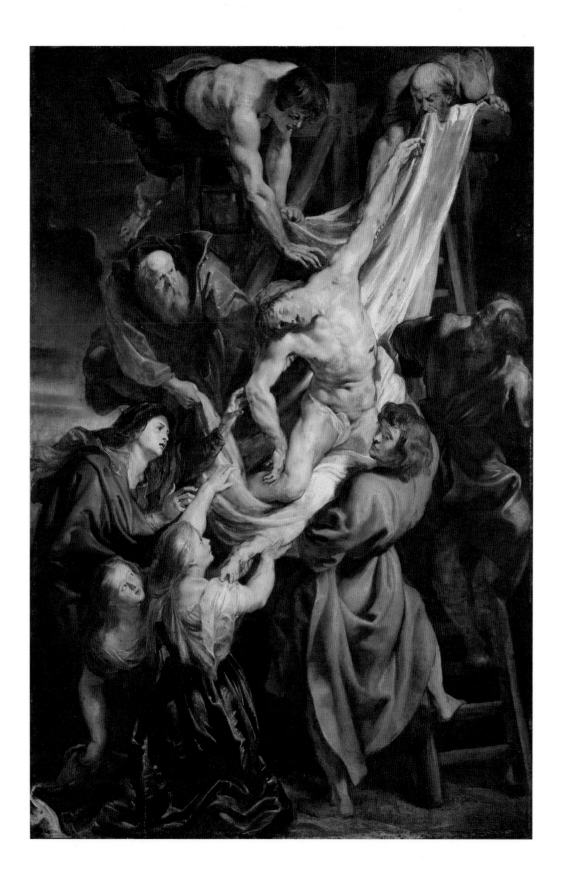

Peter Paul Rubens (1577–1640)
The Family of Jan Brueghel the Elder, around 1613–15

Oil paint on wood, 125.1 × 95.2 cm
Princes Gate bequest, 1978

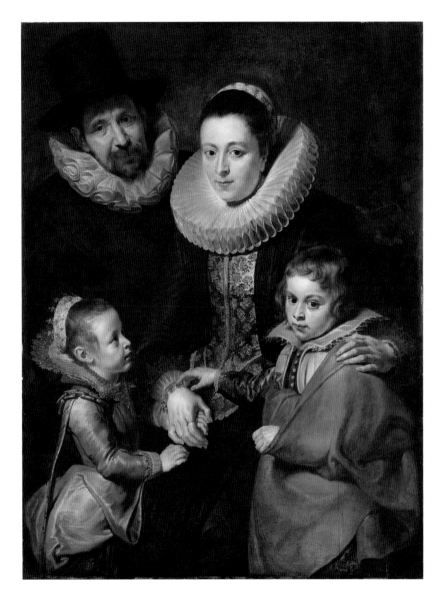

This touching portrait celebrates family and friendship, presenting the family of the painter Jan Brueghel the Elder (1568–1625) by his close friend and collaborator Peter Paul Rubens. The two artists often worked together on paintings, with Brueghel creating still-life elements and landscapes, while Rubens contributed the figures. However, no indication of Brueghel's artistic profession is given; rather, the family members wear their finest clothes and are presented as wealthy citizens of Antwerp. Brueghel's wife, Catharina (died 1627), is at the heart of the tight group, surrounded by her children Pieter (1608–1625) and Elisabeth (1609–1625). Their hands meet tenderly in the centre. Rubens added the figure of Brueghel at a late stage, painting him over the dark background.

The dating of the work is based on the children's probable ages. It is also a record of their short lives: they both died, along with their father, during the cholera epidemic of 1625.

Peter Paul Rubens (1577–1640)
Landscape by Moonlight, around 1635–40

Oil paint on wood, 64 × 90 cm
Purchased from the estate of Count Antoine Seilern
with assistance from the National Heritage Memorial Fund
and MGC/V&A Purchase Grant Fund, 1981

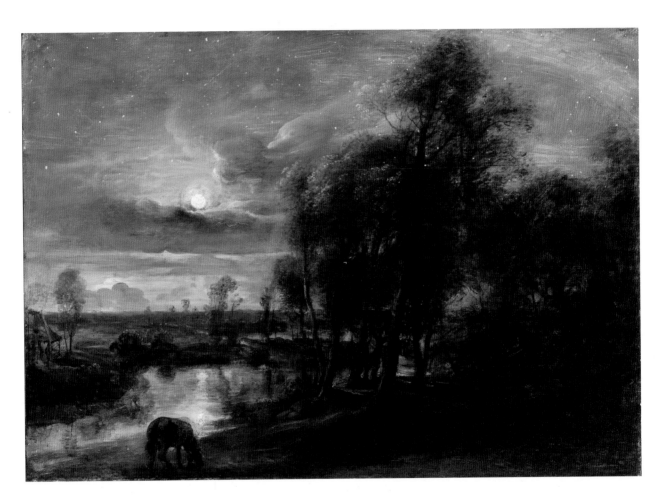

In the final years of his life, Peter Paul Rubens purchased a country estate outside Antwerp, called Het Steen. He spent long periods there, painting landscapes for his own pleasure rather than for profit. This stunning moonlit scene is one of the finest examples of the works made during that period. While Rubens was very interested in astronomy, the stars here are more like joyous flecks of paint than a carefully observed night sky. Rubens had initially included biblical figures in the foreground, but painted them out to make this picture a pure landscape. A grazing horse in the foreground is the only living creature to remain.

In the eighteenth century, this painting belonged to Joshua Reynolds, first president of the Royal Academy, who used it as an example in his lectures on art. The painting also had a powerful influence on British landscape painters such as John Constable.

Peter Paul Rubens (1577–1640)

Helena Fourment, around 1630–31

Black, red and white chalk on laid paper,
with later additions of pen and brown ink and white bodycolour
61 × 55 cm
Princes Gate bequest, 1978

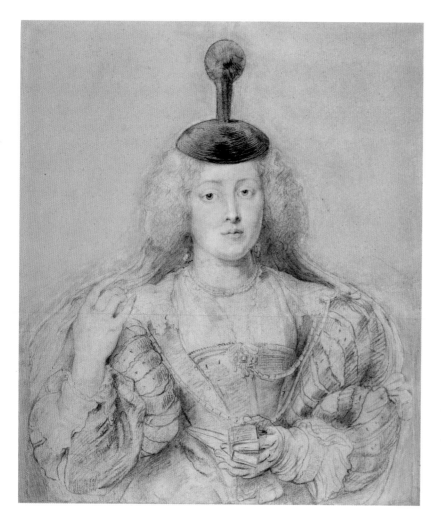

The richly dressed young woman depicted here, holding a prayer book in one hand and drawing back her veil with the other, is Helena Fourment (1614–1673). The daughter of an Antwerp silk merchant, she married Peter Paul Rubens in 1630 when she was 16 and Rubens, a widower, was 53. Rubens shows her as near life size, rendered in a delicate combination of subtly handled black, red and white chalks, celebrating her beauty and his own skill as an artist. Her pompom-topped cap with a veil attached was known as a *huyck*; although fashionable as an outdoor accessory, its presence in a portrait is highly unusual. Rubens derived Helena's apparently natural gesture of lifting her veil, expressing modesty, from a celebrated classical sculpture, the *Venus Pudica* ('modest Venus'). The drawing thus serves both as a portrait of a real, living woman and as an evocation of ideal beauty and marital virtue.

Rembrandt van Rijn (1606–1669)
Saskia Sitting up in Bed, Holding a Child, around 1635

Red chalk on laid paper, 14.1 × 10 cm
Princes Gate bequest, 1978

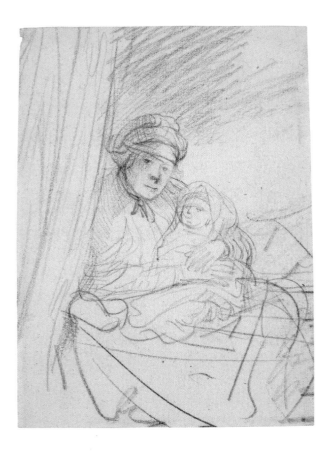

Rembrandt's first wife, Saskia Uylenburgh (1612–1642), often posed for him, appearing in the guise of a goddess or queen in some of his major paintings. By contrast, in this intimate and seemingly spontaneous sketch, Rembrandt captures her in a private domestic moment. Saskia sits up in bed, cradling their tightly swaddled child. She appears from behind a curtain, which partially shadows her softly modelled face, itself framed by the lines of the headdress and knotted ribbon around her neck. She looks directly at Rembrandt as he sketches her, his free and cursory use of red chalk emphasising the drawing's informal and private character.

The couple married in 1633 and had four children, but only one, Titus, born in 1641, lived beyond infancy. This work is usually dated to the 1630s, suggesting that the child depicted may be one of Titus's siblings who did not reach adulthood.

Thomas Gainsborough (1727–1788)
Portrait of Margaret Gainsborough, around 1778

Oil paint on canvas, 76.6 × 63.8 cm
Samuel Courtauld gift, 1932

This intimate portrait may have been painted to celebrate the fiftieth birthday of Thomas Gainsborough's wife, Margaret (around 1728–1798). He portrayed her several times during their 42-year marriage. Her direct gaze – an unusual feature in portraits of women at the time – reveals the close relationship between painter and sitter. Gainsborough creates a striking contrast between his meticulous observation of Margaret's face and the loose rendering of her dress and black shawl, vividly evoked with a few zigzags of paint.

Margaret Burr, the illegitimate daughter of Henry, third duke of Beaufort, married Gainsborough in 1746, when she was 18 and he a year older. Margaret's income from her late father's estate helped establish her husband's artistic career and she played an important role in managing his business. This picture might have served to advertise Gainsborough's talents as a portrait painter. Potential clients coming to his studio (and home) could easily compare the portrait with its model.

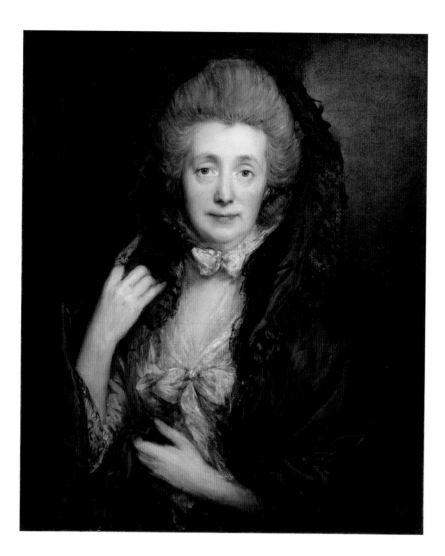

Joshua Reynolds (1723–1792)

Cupid and Psyche, around 1789

Oil paint on canvas, 139.8 × 168.3 cm
Accepted by HM Government in lieu of Inheritance Tax
and allocated to the Samuel Courtauld Trust, 2004

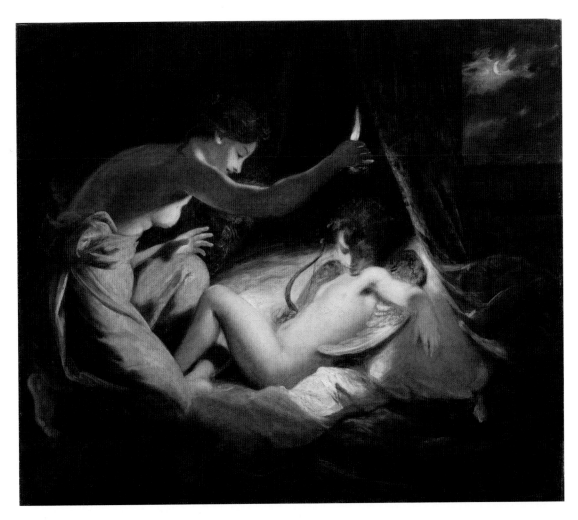

The mythological love story between the god Cupid and the beautiful mortal Psyche was a popular theme in painting. Known primarily through an ancient Roman text by Apuleius, the tale recounts how the goddess Venus, enraged by Psyche's beauty, ordered her son Cupid to have Psyche killed by a monster. Instead, Cupid fell in love with her and kept her hidden in his palace, visiting her at night, cloaked in darkness. Here, Joshua Reynolds depicted the moment when Psyche finally discovered Cupid's true identity. A drop of oil from the lamp she holds is about to wake him and he will abandon her for breaching his trust.

Reynolds, first president of the Royal Academy, unveiled this striking painting at the Academy's annual exhibition in 1789. He used the story's nocturnal setting to explore the rendering of light in painting and lavished particular attention on the alabaster-like body of the sleeping Cupid.

Tea kettle with stand, 1748-49
Samuel Courtauld I (1720–1765)

Silver, raised, embossed, punched, engraved and cast
38.6 cm (h)
On long-term loan from AkzoNobel

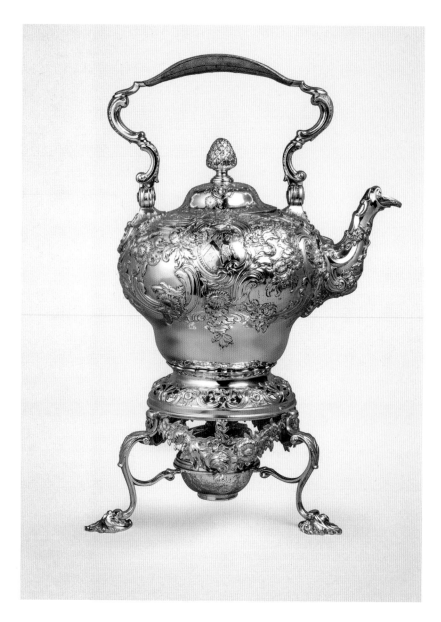

The Courtauld family of silversmiths were part of the diaspora of around 200,000 Protestant refugees, known as Huguenots, who fled religious persecution in France and were exiled across Europe. The first Courtauld settled in London in the late 1680s and worked in the wine trade. His son Augustin trained as a silversmith, opening a workshop in London's Soho district in 1729, an area popular with Huguenot artists and designers. The designer of this sculptural rococo tea kettle and stand was Augustin's son Samuel.

In 1780, the Courtauld silver business was sold and the family turned to silk weaving, eventually founding the textile company Courtaulds Ltd. Its chairman in the 1920s was Samuel Courtauld IV, who presented his famous collection of Impressionist paintings to the Courtauld Institute of Art, which he helped to found (see pp. 9–15).

Condiment vase with cover

Louisa Perina Courtauld (1729–1807)
and **George Cowles** (died in 1811)

Silver, raised, cast and engraved
19.3 cm (h)
On long-term loan from AkzoNobel

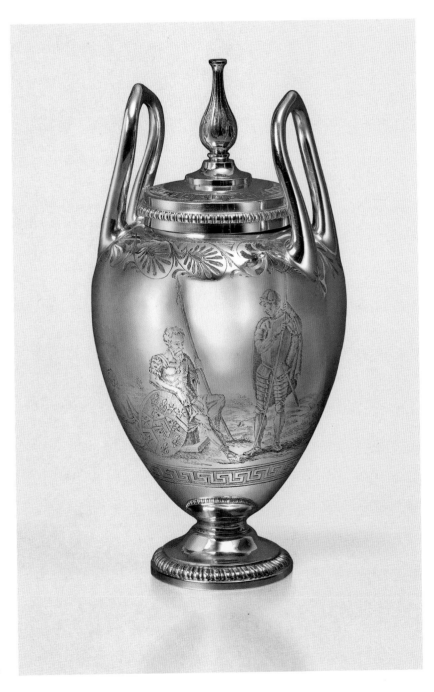

Upon Samuel Courtauld I's death, his widow, Louisa, continued the family business. The works she made in association with George Cowles, Samuel's former apprentice, were in the more intellectual and pared-down neoclassical style then in fashion. This condiment vase is a fine example of their work.

Francisco de Goya (1746–1828)

Portrait of Francisco de Saavedra, 1798

Oil paint on canvas, 116.5 × 89.5 cm
Viscount Lee of Fareham bequest, 1947

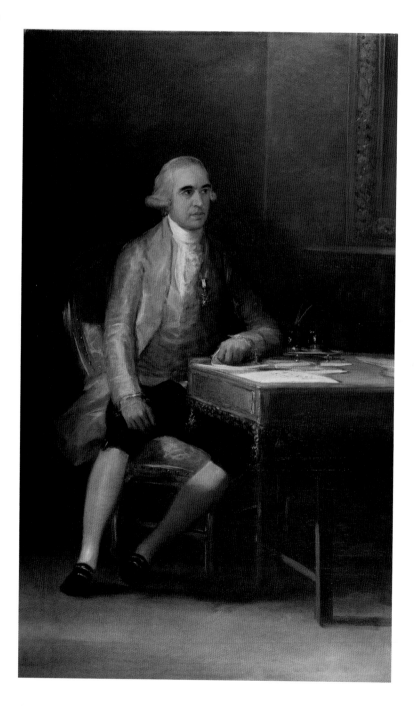

The loose brushwork and speed of execution in this imposing painting set it apart from the usual formality and polish of full-length portraits at this time. With only a few strokes of paint, Francisco de Goya rendered the texture of the sitter's silk coat, as well as the papers and inkwells on the table. Only Francisco de Saavedra's face and hands have been carefully and thickly modelled.

When he posed for Goya, Saavedra (1746–1819) had recently been appointed Minister of Finance to King Charles IV of Spain. The painting was commissioned by his friend and then Minister of Justice, Gaspar Melchor de Jovellanos, perhaps to accompany his own portrait by Goya (now in the museo del Prado, Madrid). The two political allies were eager to bring reform to the conservative Spanish government and embodied a new, but short-lived, moment of progressive thinking. They were dismissed within a year.

Francisco de Goya (1746–1828)
Cantar y bailar (Singing and Dancing), around 1819–23

Brush and black and grey ink with scraping on laid paper, 23.5 × 14.5 cm
Princes Gate bequest, 1978

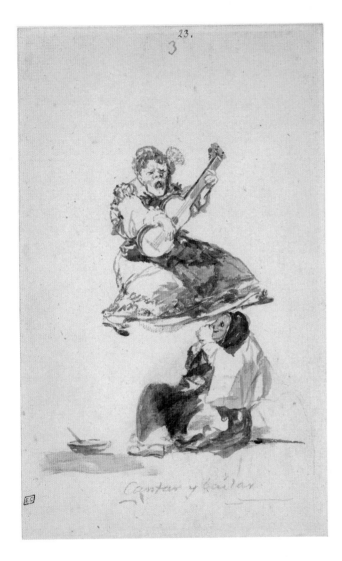

This arresting work belonged to one of Francisco de Goya's celebrated private albums of drawings, known as the 'Witches and Old Women' album. Assembled by the artist in the last decade of his life, this group of works explores his interest in themes of witchcraft, dreams and nightmares. This drawing shows an old woman levitating while playing a guitar, singing and dancing as the Spanish inscription at the bottom suggests. Another woman seated below her is dressed as a nun and seems to be either pinching her nose against an unpleasant smell, or to be holding a mask to her face. Drawings such as this were made for the artist's private enjoyment and allowed Goya to give his extraordinary imagination free rein. Although highly evocative and perhaps related to Goya's contemplation of old age, the drawing's original meaning remains elusive.

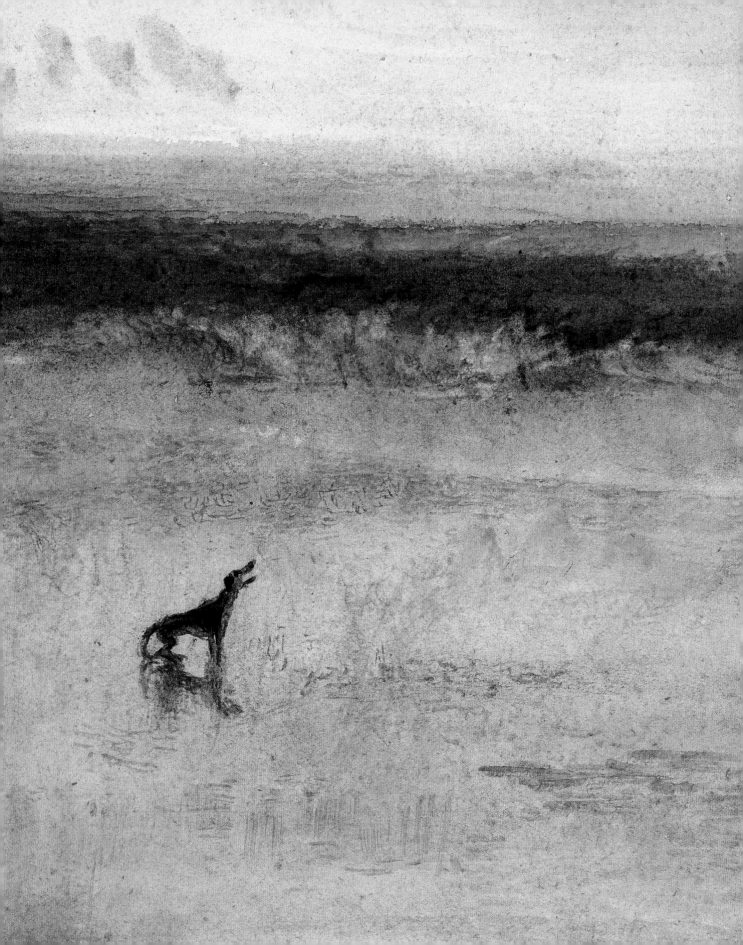

Joseph Mallord William Turner (1775–1851)
Dawn after the Wreck, around 1841

Graphite, watercolour, bodycolour and red chalk with scraping on laid paper
25.2 × 36.9 cm
Presented by Jeanne Courtauld in memory of Sir Stephen Courtauld, 1974

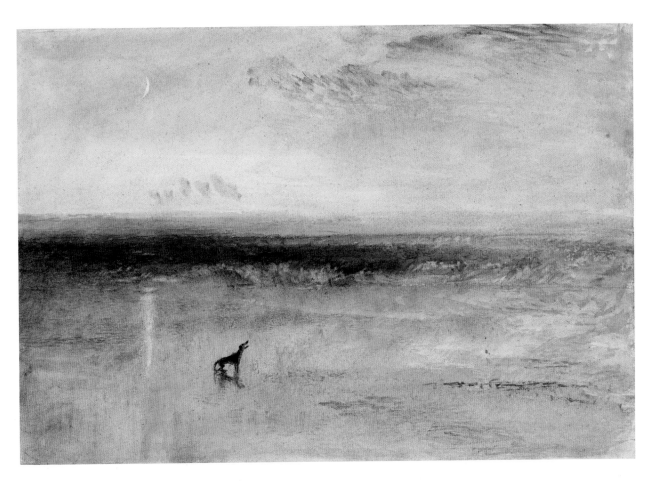

In spite of its title – invented by the Victorian critic John Ruskin – this watercolour does not directly depict the aftermath of a shipwreck, although it probably shows a stretch of the Kent coast notorious for its dangers. Several elements do, however, imbue the coastal scene with a sense of solitude and even despair: the intense palette of reds, blues and yellows, the moonlight on the sand and waves (an effect J.M.W. Turner evoked by rubbing and scratching through the watercolour wash), and the lone dog howling at the sky.

In the last two decades of his career, Turner turned away from detailed descriptions of specific locations in favour of studying the ever-changing effects of atmosphere and weather on a landscape. Rather than illustrating a specific incident, this late watercolour can be understood as an exploration of the nature and mood of the sky and sea.

Somerset House: The North Wing

Alexandra Gerstein
McQueens Curator of Sculpture & Decorative Arts

Somerset House was one of the grandest building projects of eighteenth-century Britain. Built as the result of an Act of Parliament, it was constructed between 1775 and 1801 on land formerly belonging to the Crown. Its palatial scale and extensive programme of architectural sculpture were intended to showcase Britain's commercial, military and artistic dominance during the period of British imperialism in the late eighteenth century.

In 1775, Sir William Chambers (1723–1796) was appointed architect of Somerset House [1]. Born in Sweden, Chambers travelled extensively, studying in Paris and Rome, and later becoming architectural tutor to the then Prince of Wales (later King George III). He was one of the pre-eminent architects in Britain, working in a pan-European neoclassical style.

Somerset House was built primarily as the headquarters of the Royal Navy, with space also for the Civil Service, including many government tax departments that were previously scattered across London. Chambers's first design challenge was how to tie together a series of functionally diverse buildings on an irregularly shaped site with varying ground levels. His solution was to create interconnected buildings around a deep courtyard and to aesthetically harmonise the whole in Portland stone.

At the heart of this administrative complex was the North Wing, facing the Strand. Today it is the home of the Courtauld Institute of Art. Originally, the North Wing was occupied by three of the leading cultural and scientific institutions of the British Enlightenment: the Royal Academy, the Royal Society and the Society of Antiquaries. Its beautifully detailed and colonnaded vestibule provided the formal entrance to Somerset House, leading visitors away from the hustle and bustle of what has always been one of London's busiest thoroughfares into the formal elegance of the

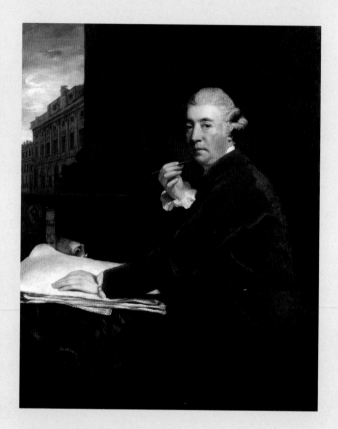

[1] Joshua Reynolds (1723–1792), *Portrait of Sir William Chambers, R.A.*, around 1780, oil paint on canvas, Royal Academy of Arts, London. Somerset House appears in the background.

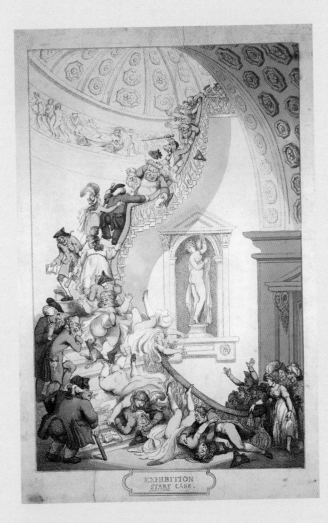

[2] Thomas Rowlandson (1757–1827), *Exhibition 'Stare' Case*, around 1811, hand-coloured etching, Princeton University Library, New Jersey. This caricature is a crude and sexist satire mocking the type of unruly visitors that undermined the Royal Academy's high ideals.

interior courtyard. From its inception, the west side of the North Wing was the only truly public space on the site, welcoming visitors to the Royal Academy's annual Summer Exhibition and to its lectures on art.

The Royal Academy was founded by King George III in 1768. It was created by 36 artists and architects as Britain's first independent arts organisation, and provided education for artists, public lectures and the first public exhibition space for contemporary art. Unusually progressive for the time, the Royal Academy allowed women to show their work in its annual exhibitions, and two of its founding members were women. Chambers was the treasurer and instrumental in obtaining royal patronage. This was the first permanent home of the Royal Academy. Through its architecture, Chambers sought to express some of its ideals about the civilising power of art. The entrance hall of the Royal Academy, now the entrance to the Courtauld Gallery, was originally filled – as much of the building was – with plaster copies of ancient Greek and Roman sculpture, from which students were required to draw as part of their training. From here visitors ascended a dramatic spiralling staircase. Critics of the Royal Academy ridiculed both the steep staircase and the fashionable visitors who flocked each year to its Summer Exhibition [2].

The first stop on this staircase was not in fact intended for visitors. It was originally assigned to the staff of the Royal Academy, and was designed as a mezzanine, or half-floor, with a lower ceiling height. The Royal Academy's Sweeper (head housekeeper) lived and worked here.

Royal Academicians and students, as well as attendees of the lectures of the learned Societies, would congregate on what is now the second floor. Much of the original decoration, marble mantelpieces and splendid plasterwork remain

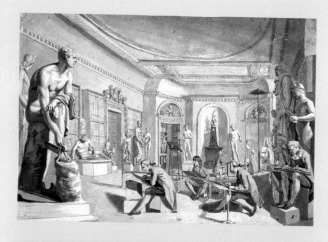

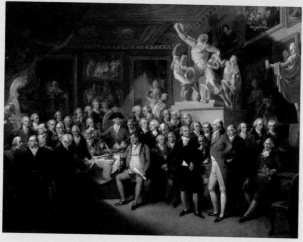

[3] Edward Francis Burney (1760–1848), *The Antique School at New Somerset House*, around 1780, pen and ink with watercolour wash on laid paper, Royal Academy of Arts, London

[4] Henry Singleton (1766–1839), *The Royal Academicians in General Assembly*, 1795, oil paint on canvas, Royal Academy of Arts, London. Although the Royal Academy admitted women and allowed them to exhibit, women members were not allowed to attend its General Assembly. Singleton used his artistic licence to show the two founding female members, Mary Moser and Angelica Kauffman, as though they were present, at the back of the room.

in place. Chambers made sure that the Royal Academy's spaces received the most sumptuous treatment of all the rooms on this floor. A library served as the ante-room (lobby) to a room known as the Antique School, where students learned to draw after plaster casts of Greek and Roman sculpture [3]. The most prestigious and lavish of the Academy's rooms was the Council Room, decorated with a spectacular plasterwork ceiling by Thomas Collins [4]. Originally embellished with paintings by the American artist Benjamin West and the Swiss painter Angelica Kauffman, both founding Academicians, these were replaced with sepia photographs in the twentieth century. The original works are still with the Royal Academy in Piccadilly.

Initially, only one other learned society – the Royal Society – was meant to share the floor with the Royal Academy. However, when the Society of Antiquaries heard of this plan, they used their political influence to be granted rooms in the new building. The public lectures of the Royal Society, founded in 1660 and, to this day, the United Kingdom's leading science academy, were held in their Council Room. On topics ranging from mathematics and astronomy to biology and physics, groundbreaking lectures delivered here included William Herschel's announcement of his discovery of the planet Uranus in 1781 and one of the first demonstrations of modern photography, in 1839.

The Society of Antiquaries, created in 1707 to study and record ancient monuments, would become, over the next two centuries, the leading advocate for their conservation. The Rosetta Stone, for example, was displayed in their Library as soon as it arrived from Egypt, where it had been handed over to British forces by the French as part of the Treaty of Alexandria in 1801.

The Royal Academy's annual Summer Exhibition, showing the best of British contemporary

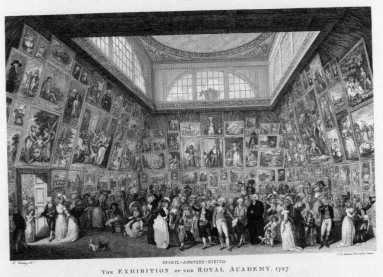

[5] Pierre Antoine Martini (1739–1800), *The Exhibition of the Royal Academy*, 1787, etching, Rijksmuseum, Amsterdam

art, took place in the Great Room on the top floor. The Academy has staged an exhibition every year since 1769. In its first year at Somerset House, in 1780, more than 60,000 people visited and over 200 artists submitted work. Over the years, the number of exhibits increased, more than tripling in the first 40 years. The majority of exhibits were paintings and the overwhelming proportion of exhibitors were men. Turner, Constable, and Reynolds were among the artists who showed their work. The annual exhibition was a celebrated spectacle, and the Great Room became a stage for society as well as art [5].

The Great Room was the first purpose-built exhibition space in the United Kingdom, and the first top-lit public gallery in Europe. The large windows and roof rested on concealed beams, allowing the central space to remain completely open. At the time, it was celebrated as the largest unsupported span in London. The ceiling was painted to mimic the sky and a moulding known as 'the Line' encircled the room at door-frame height. Paintings were arranged in dense frame-to-frame displays, and artists competed fiercely to have their works placed along 'the Line', one of the most prominent locations in the room.

Here, senior Academicians also delivered their Discourses (lectures) on art to the public.

These were popular and, in a famous anecdote, a beam in the roof cracked when 200 people came to hear Joshua Reynolds's lecture on Michelangelo in 1790.

By 1837, the Royal Academy had outgrown its premises. It moved first to the National Gallery in Trafalgar Square and later to Burlington House in Piccadilly, where it remains today. The learned societies moved out subsequently and the North Wing of Somerset House was taken over by government offices. In 1990, it became the permanent home of The Courtauld.

Camille Pissarro (1830–1903)

Lordship Lane Station, Dulwich, 1871

Oil paint on canvas, 44.5 × 72.5 cm
Samuel Courtauld bequest, 1948

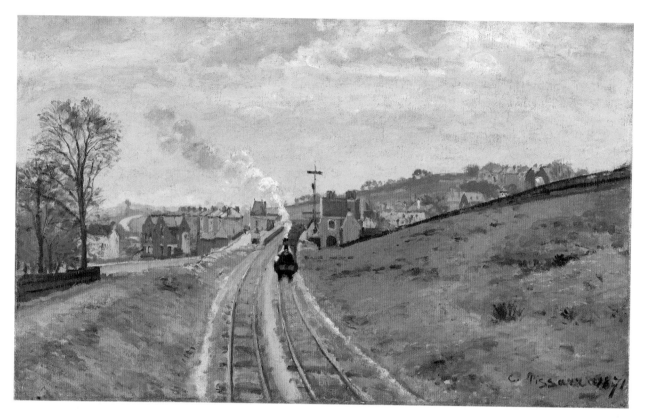

Painted from a footbridge spanning the tracks, this painting shows a train leaving a station in south London. The diminutive train, chugging steadily toward the viewer, appears almost toy-like; puffs of steam from the engine merge with the overcast sky. Camille Pissarro fled Paris with his family in 1870, during the Franco-Prussian War, and remained in London for over a year, largely devoting himself to painting the city's southern outskirts, where he lived. Although the landscape depicted here was in the process of being transformed from open countryside to built-up suburbs, it is strangely devoid of people. Pissarro originally included a man on the grassy slope on the right but later painted him out.

At the time, trains and railways were an uncommon subject for a painting. In this work, Pissarro pioneered a motif that would be embraced by his fellow Impressionists as an icon of modern urban life.

Eugène Boudin (1824–1898)

Deauville, 1893

Oil paint on canvas, 50.8 × 74.2 cm
Samuel Courtauld bequest, 1948

Eugène Boudin made his name depicting fashionable Parisian visitors at the seaside resorts of his native Normandy. Later, he turned to painting open landscapes with fewer people. The figures in this scene – beachgoers and local fishermen with their horse-drawn cart – are indicated with quick brushstrokes. The principal subject here is the sky, which occupies nearly three-quarters of the canvas, and the play of light over the vast expanse of sand and clouds. Boudin's commitment to painting outdoors inspired Claude Monet, who worked alongside him in the 1860s. However, Boudin's technique differs markedly from that of the younger artist. His brushwork is more precise and he painted the sky more broadly and thinly, here allowing the brown preparation layer of the canvas to show through in patches, creating shadows within the clouds. Despite its apparent spontaneity, the painting shows signs of extensive reworking, probably done in the studio.

Pierre-Auguste Renoir (1841–1919)
La Loge (The Theatre Box), 1874

Oil paint on canvas, 80 × 63.5 cm
Samuel Courtauld bequest, 1948

Pierre-Auguste Renoir showed *La Loge* at the first Impressionist group exhibition in Paris in 1874. The painting was designed to make an impact: its modern subject of a contemporary, fashionable-looking couple in a box at one of Paris's premiere theatres was unprecedented in painting. Renoir's tightly cropped composition, giving the sense of a snapshot of modern life, was highly unconventional. In addition, his careful staging of the figures in stereotypically gendered roles – the woman having lowered her opera glasses to become the focus of attention, the man raising his to look at someone in the audience – creates an intriguing game of gazes, surely intended to provoke comment.

Indeed, critics responded extensively to the painting. Some admired Renoir's new subject matter and his painterly technique, praising his 'qualities of observation and remarkable qualities of colour'. However, several reviewers were troubled by the appearance of Renoir's couple, especially the woman. They were concerned that she was not a respectably married member of fine society, but rather a victim of fashion – overly dressed and excessively made-up, trying to push her way onto the social scene.

Although new to painting in 1874, theatre box subjects were a familiar feature of French fashion magazines, where they provided a stage for illustrations of women modelling the latest evening wear. *Loges* were also often pictured in satirical journals as a setting to poke fun at their occupants' social foibles or romantic liaisons. Renoir's *La Loge* contains aspects of both contemporary fashion and satire, but his main concern was in demonstrating his dazzling painting technique. The scene was carefully arranged in the artist's studio, with a model called Nini Lopez posing for the woman and Renoir's brother, Edmond, for the male figure, in order for Renoir to create a symphony in black and white. The bold stripes of the woman's highly fashionable dress are a flamboyant counterpoint to the man's similarly coloured but subdued evening attire. Renoir's brushwork is delicate and fluent throughout. The virtuoso performance of works such as *La Loge* soon established Renoir as one of the leading Impressionist painters of his generation.

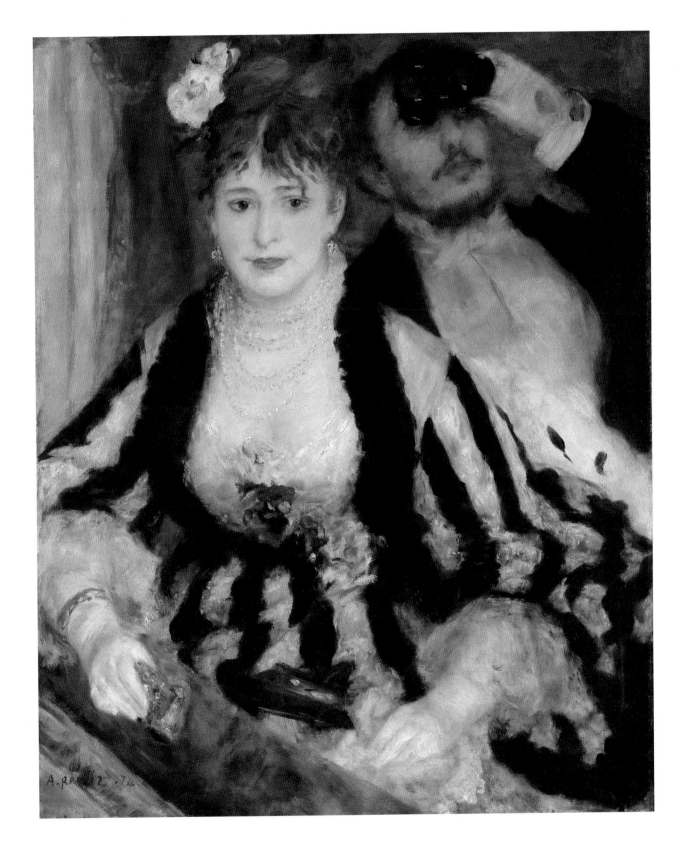

Édouard Manet (1832–1883)
Study for Le Déjeuner sur l'herbe (Luncheon on the Grass), around 1863

Oil paint on canvas, 89.5 × 116.5 cm
Samuel Courtauld gift, 1932

This work was made in preparation for one of the most famous paintings of the nineteenth century, *Le Déjeuner sur l'herbe* (*Luncheon on the Grass*, now in the musée d'Orsay, Paris). In 1863, Édouard Manet scandalised the art world with his life-size depiction of two nearly naked women alongside fully dressed men in contemporary clothes, a juxtaposition that was judged indecent. Although Manet initially drew inspiration from Renaissance pastoral scenes, he rejected the veil of mythology and painted realistic female figures, one of whom confronts the viewer with her direct gaze.

As with most studies, some areas are loosely defined, others more fully painted. Here, Manet lavished particular attention on the trunk of the tree on the left and the black jacket of the reclining male figure. This large study was most likely painted as an aid during the creation of the large canvas, which took over a year to complete.

Édouard Manet (1832–1883)
Banks of the Seine at Argenteuil, 1874

Oil paint on canvas, 62.3 × 103 cm
Formerly in the collection of Samuel Courtauld
On long-term loan from a private collection

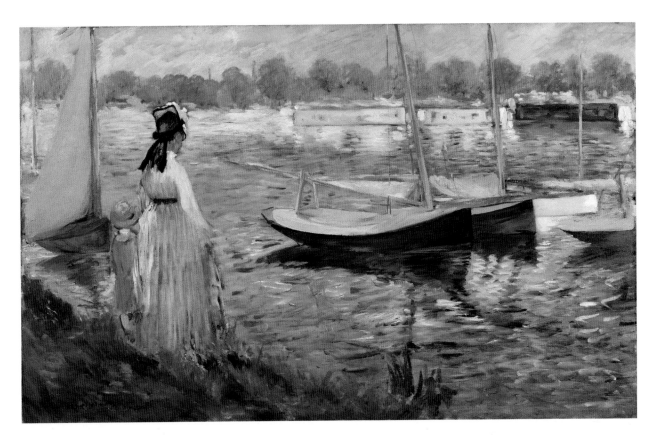

In 1874, Édouard Manet spent the summer with Claude Monet, who was living in the town of Argenteuil, just outside of Paris. Although Manet had refused an invitation to exhibit his works in the first Impressionist exhibition earlier that year, he was close to members of the group and interested in their new approach of painting outdoors. *Banks of the Seine at Argenteuil* is one of Manet's most vivid experiments in that vein. The bright colours and swift brushstrokes creating the ripples on the water show Monet's influence.

However, Manet had little interest in effects of light. He maintained his distinctive use of thick oil paint and rich blacks to give weight to the painting.

The painting's subject demonstrates Manet's attentiveness to the changing society of his time. He juxtaposed the sailboats in the foreground, used for leisure by weekend visitors, with the long barges in the background, where the working class came to wash laundry in the river.

Édouard Manet (1832–1883)
A Bar at the Folies-Bergère, 1882

Oil paint on canvas, 96 × 130 cm
Samuel Courtauld gift, 1934

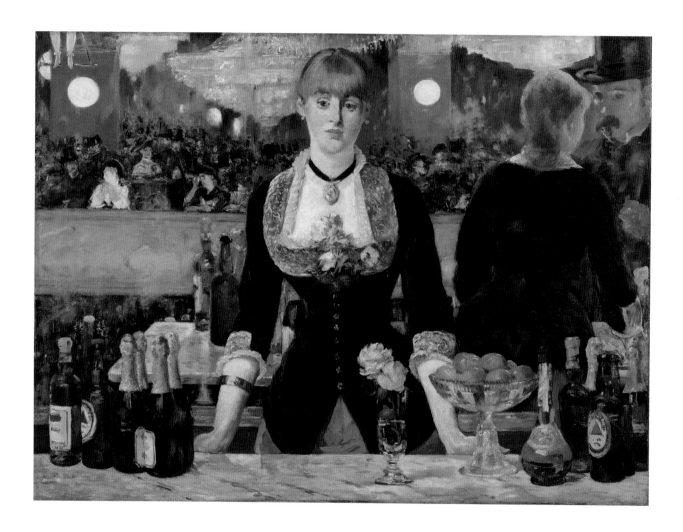

This celebrated work is Édouard Manet's last major painting, completed a year before he died, and exhibited at the Salon of 1882 (the official annual exhibition of the French Academy of Fine Arts in Paris). This would have been a startling painting for Salon visitors in many ways, not least because it seems to follow the traditional format of portraiture but does not name its subject. Indeed, the barmaid appears as just another item in the enticing array on offer in the foreground: wine, champagne, peppermint liqueur and British Bass beer, with its iconic red triangle logo. The background shows a fashionable crowd mingling on the balcony, entertained by musical and circus acts, represented by the legs and green boots of the trapeze artist in the top left corner. This animated scene is in fact a reflection in the large gold-framed mirror, which projects it into the viewer's own space.

Opened a decade or so earlier, the Folies-Bergère had rapidly become one of most popular music halls and entertainment venues in Paris. Manet frequented it with friends and made sketches on site. However, the final work was painted entirely in his studio, where a barmaid named Suzon came to pose. She is the painting's still centre. Her enigmatic expression is unsettling, especially as she appears to be interacting with a male customer, shown in the mirror. Ignoring normal perspective, Manet has shifted the couple's reflection to the right. The bottles on the left are similarly misaligned in the mirror. This play of reflections emphasises the disorientating atmosphere of the bustling Folies-Bergère. In *A Bar at the Folies-Bergère*, Manet created a complex, absorbing composition and one of the iconic paintings of modern life.

Edgar Degas (1834–1917)
Two Dancers on a Stage, 1874

Oil paint on canvas, 61.5 × 46 cm
Samuel Courtauld gift, 1932

Edgar Degas was fascinated by ballet, producing over a thousand works on the subject, ranging from drawings and pastels to sculptures and paintings. This canvas depicts two young dancers performing in full costume and illuminated by stage lights. A third dancer, just visible to the left-hand side, may be at rest, suggesting this could be a dress rehearsal, as Degas was often granted access to these.

Degas captures the central figure *en pointe*, a delicate-looking, but demanding, position whereby the dancer elevates herself on just the end of her toes. The painting presents a view from the side of the stage, as if observed from the wings. Degas favoured such unconventional viewpoints, which he uses here to heighten the drama and complex movements of the dancers. The parallel lines on the floor, probably tracks for sliding scenery, emphasise the artist's dynamic composition while evoking the staging of the ballet itself.

Edgar Degas (1834–1917)
Dancer Looking at the Sole of her Right Foot

Around 1919–20, from a wax model made around 1895–1900
Bronze, cast by A.A. Hébrard Foundry, 45.5 cm (h)
Accepted by HM Government in lieu of Inheritance Tax
and allocated to the Samuel Courtauld Trust, 2010

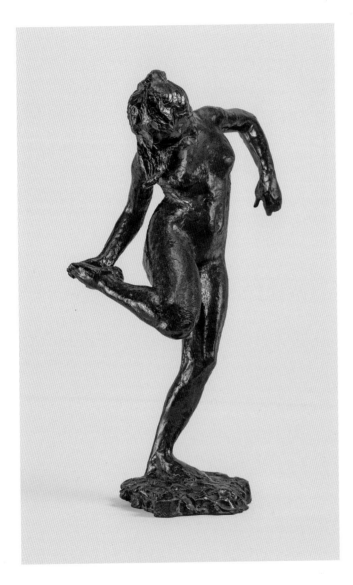

Approximately one hundred and fifty clay and wax sculptures, mostly of dancers and horses, were left in Edgar Degas's studio on his death. His family had a number of these cast in bronze. Private and experimental works, the originals were often strengthened with ordinary items such as cork or matches.

In his sculptures of dancers, Degas sought to capture the female body in motion and in strenuous ballet postures. Many of his models were young and impoverished ballerinas at the Paris Opéra. In 1910, one of his regular models, known only as Pauline, described the physical strain of holding this posture, which she did repeatedly over many sessions. Four sculptures and numerous drawings feature this pose. This beautiful bronze, with its olive-green patina evocative of the original wax and plaster sculpture, was formerly in Samuel Courtauld's collection.

Edgar Degas (1834–1917)
Woman at a Window, around 1871

Oil paint on paper, pasted on linen,
61.3 × 45.9 cm
Samuel Courtauld gift, 1932

Edgar Degas's silhouetted female sitter appears serene yet, according to the English artist Walter Sickert, who knew Degas, this work was painted around the time of the siege of Paris by the Prussians in 1871. Sickert recalled that Degas paid his model with a hunk of meat 'which she fell upon, so hungry was she, and devoured raw'.

This is one of the artist's most technically experimental works. He used *essence*, paint drained of its oil and thinned with turpentine, resulting in a medium with a matte effect that can be handled like watercolour. Degas thus explored the interchangeability of drawing and painting, creating fluid outlines with thinned black paint and opaque white highlights. While this painting appears unfinished, it is signed, indicating it was intended for sale.

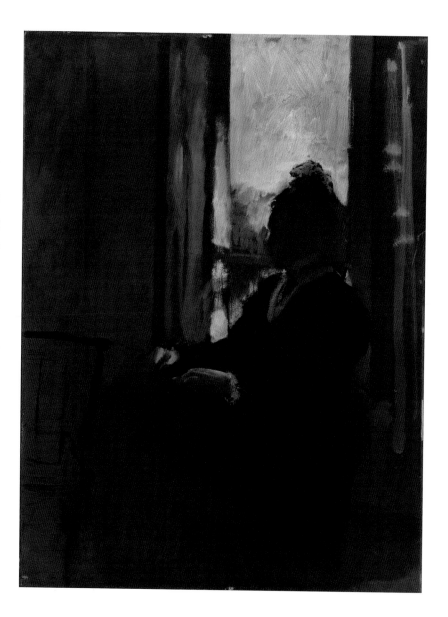

Paul Gauguin (1848–1903)
Portrait of Mette Gauguin, 1877

Marble, 34 cm (h)
Samuel Courtauld gift, 1932

This bust of Mette, Paul Gauguin's Danish wife, is one of only two marble sculptures he ever made. The other is of their son Emil. Both were created early in Gauguin's artistic career. The finely ruffled collar and gap between collar and neck demonstrate a technical proficiency surprising in someone with no formal sculptural training. He was likely helped by a professional sculptor, Jules-Ernest Bouillot, his landlord at the time. The marble is restrained compared to Gauguin's later sculpture, especially his roughly chiselled wood carvings. Gauguin signed the sculpture and exhibited it at the fifth Impressionist exhibition in Paris in 1880.

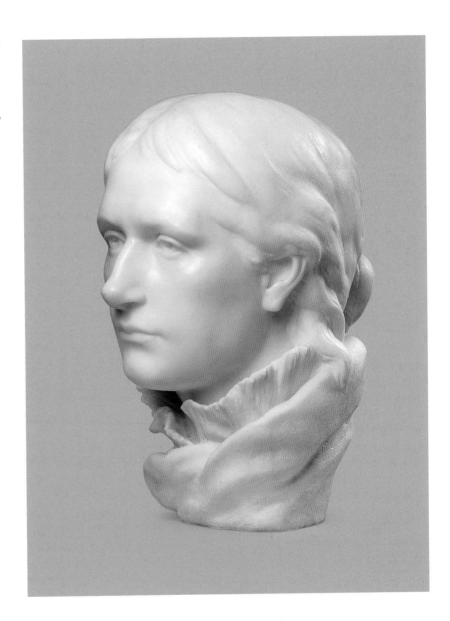

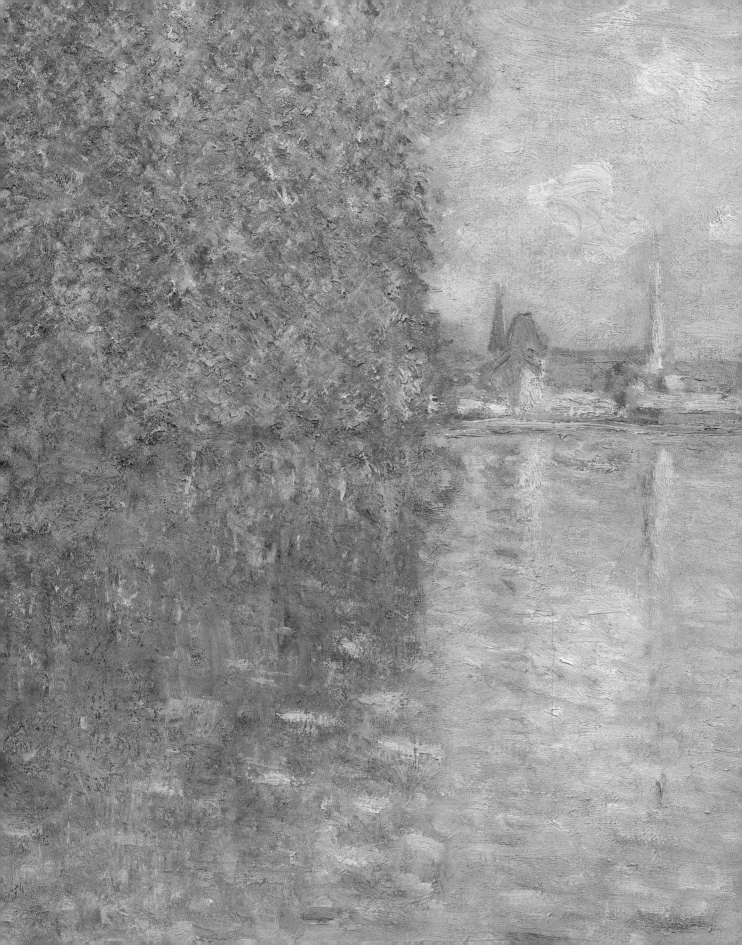

Claude Monet (1840–1926)
Autumn Effect at Argenteuil, 1873

Oil paint on canvas, 55 × 74.5 cm
Samuel Courtauld gift, 1932

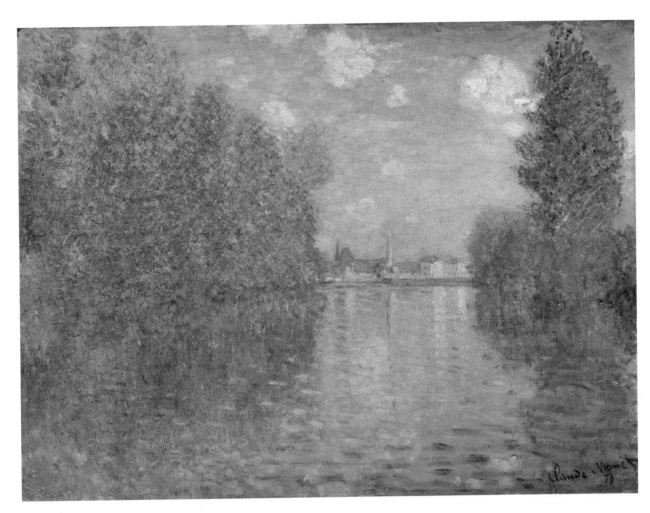

Claude Monet lived in Argenteuil, a suburb of Paris, from 1871 to 1878. It was an affordable alternative to the capital, easily accessible by the new railroads. A formerly rural town undergoing rapid industrial change, it also offered Monet a uniquely modern landscape. He painted this view of the river Seine and the town beyond from his specially designed studio boat, moored on a quiet side channel. Although parts of Argenteuil's townscape can be recognised in the background, the real subjects of this work are the flamboyant autumnal colours and the effects of light and wind on ripples. The fluttering orange leaves contrast with the blue water, rendered as thick parallel lines. Monet added texture to the trees by scratching into the paint with the handle of his brush.

Autumn Effect at Argenteuil was included in the second Impressionist exhibition in 1876. When shown in London in the 1880s, critics praised the freshness and vibrancy of its colour.

Claude Monet (1840–1926)

Vase of Flowers, begun in 1881

Oil paint on canvas, 100.4 × 81.8 cm
Samuel Courtauld gift, 1932

In the early 1880s, Claude Monet focused on painting floral still lifes. This lush bouquet of mallows (a wildflower) is set against a background rendered in overlapping strokes of sparkling colour. The off-centre placement of the vase and the unusually high viewpoint create the unsettling feeling that the table and flowers are tilting forward. The blossoms and leaves are rendered in short dabs of paint that convey a raw, unfiltered impression, in keeping with Monet's interest in vision as the pure sensation of light and colour. The heavily worked surface hints at the difficulties Monet experienced in resolving the painting. He kept the canvas in his studio for decades, only signing and selling it in around 1920. The artist's own long-standing dissatisfaction with the painting was clearly not shared by collectors; in fact, this was the first painting by Monet purchased by Samuel Courtauld.

Claude Monet (1840–1926)

Antibes, 1888

Oil paint on canvas, 65.5 × 92.4 cm
Samuel Courtauld bequest, 1948

In early 1888, Claude Monet travelled to the south of France where he spent several months capturing the intense colours and light of the Mediterranean coast. This view of a wind-battered pine beside the sea, in the town of Antibes, was one of seven paintings of this subject resulting from his trip. At first, Monet needed time to acclimatise to the strong light and hot colour, lamenting that he 'would need a palette of diamonds and jewels' to capture the

effect of sunlight striking the sea and shore. As this painting demonstrates, he found a solution by both heightening the intensity of his colours and skilfully managing their contrast, setting intense blues and greens against sharp accents of pink and orange. The silhouetting of the tree reflects Monet's interest in Japanese art, in which this motif often appears; he often drew upon his knowledge of Japanese prints to help him approach unfamiliar landscapes.

Paul Cézanne (1839–1906)
Montagne Sainte-Victoire with Large Pine, around 1887

Oil paint on canvas, 66.8 × 92.3 cm
Samuel Courtauld gift, 1934

The Montagne Sainte-Victoire, with its distinctive craggy, broken top, dominates the countryside surrounding Paul Cézanne's hometown of Aix-en-Provence in southern France. For him, it embodied the rugged landscape and people of Provence. Cézanne painted and drew the mountain from different vantage points throughout his career, each time finding a new mood or atmosphere. This painting is the most monumental and highly finished of three canvases he devoted to this particular view. Here, Cézanne used contrasting colour to suggest a feeling of expanse and breadth. Areas of green and yellow lead the eye to the towering Sainte-Victoire, painted in cool blues and pinks; tiny touches of red in both the foreground and background create a sense of visual unity. The sweeping pine branches in the foreground follow the contours of the mountain; this was one of Cézanne's favourite framing devices and it is also found in *Lac d'Annecy* (see pp. 92–93). The timeless quality of the setting is interrupted only by the modern railway viaduct on the right.

When the painting was first shown at an exhibition of amateur artists in Aix, it was met with incomprehension. Cézanne ended up giving it to the poet Joachim Gasquet in appreciation of the young man's sincere admiration. It is one of the very few paintings signed by Cézanne after 1880. The artist's critical fortunes had changed dramatically by the time Samuel Courtauld encountered his work – he recalled feeling 'the magic' when he first saw one of Cézanne's paintings in 1922. His passion for the artist led him to build an important collection of his paintings and drawings; as a result, The Courtauld has the largest group of works by Cézanne in the United Kingdom.

Paul Cézanne (1839–1906)
The Card Players, around 1892–96

Oil paint on canvas, 60 × 73 cm
Samuel Courtauld gift, 1932

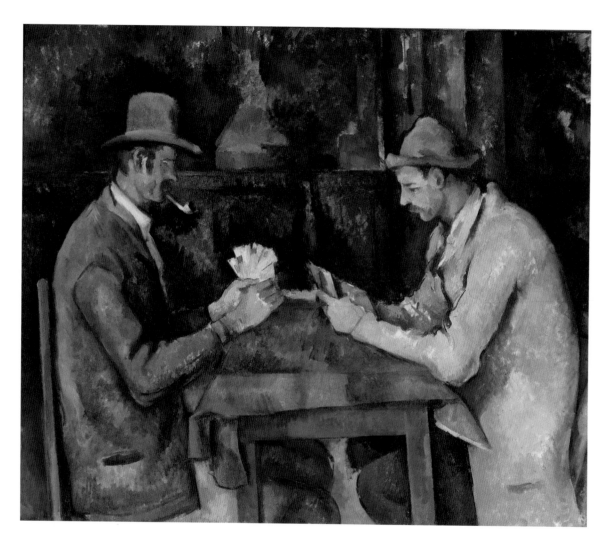

Paul Cézanne spent several years drawing and painting farmworkers from the rural estate where he lived near Aix-en-Provence, in the south of France. This is one of five paintings depicting some of these men playing cards. The figure on the right is a gardener named Paulin Paulet. The other figure remains unidentified; Cézanne made a separate portrait of him, which is also in The Courtauld's collection (see opposite).

Cézanne's figures are elongated, somewhat out of proportion, and his brushwork is lively and varied. However, the overall feeling in the painting is one of stillness and concentration, with the men completely absorbed in their game. Before Cézanne, artists and illustrators often represented card playing as a rowdy, drunken activity in taverns. This painting offers a different vision: Cézanne's labourers are monumental and dignified, like timeworn statues.

Paul Cézanne (1839–1906)
Man with a Pipe, around 1892–96

Oil paint on canvas, 73 × 60 cm
Samuel Courtauld gift, 1932

A farmworker from Paul Cézanne's family estate posed for this painting. He also appears as a card player wearing the same hat and smoking a clay pipe in another of the artist's works, *The Card Players* (opposite). It was unusual at this time for a rural labourer to be made the subject of a portrait, but it was typical of Cézanne to defy convention and paint what interested him most. The sitter's name, however, is not recorded so the man remains anonymous. Cézanne seems to have carefully considered every brushstroke in order to breathe life into the limited tonal range of browns that comprise the man's clothes and background. This is achieved with a wide range of lively, short brushstrokes that subtly animate the picture. The man is portrayed as a stoical figure, his weathered face suggesting a working life spent outdoors. Cézanne made a number of paintings of rural workers at this time. He wrote, 'I love above all the appearance of people who have grown old without breaking with old customs'.

Paul Cézanne (1839–1906)
Lac d'Annecy (Lake Annecy), 1896

Oil paint on canvas, 65 × 81 cm
Samuel Courtauld gift, 1932

In 1896, Paul Cézanne went on holiday with his family to the French Alps. This view of the mountain lake of Annecy, near the Swiss border, was the only painting he made during the trip. He struggled with what he considered an overly charming and conventionally picturesque setting, which differed markedly from the rugged landscape of his native Provence. Yet, this emerges as one of his most daring paintings.

Cézanne explored his surroundings in terms of form and colour and rearranged elements of the landscape to create a more harmonious composition. He transformed the distant castle into a combination of severe geometric shapes and rendered the light and shadow on the mountain slopes with contrasting, segmented colours. The tree at the left is bathed in sunlight, lending the painting a touch of warmth.

Paul Cézanne (1839–1906)

Still Life with Plaster Cupid, around 1894

Oil paint on paper, 70.6 × 57.3 cm
Samuel Courtauld bequest, 1948

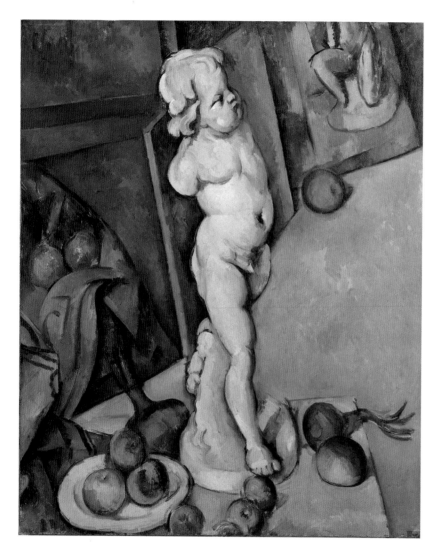

With this painting, Paul Cézanne challenged a popular view that still life was an unadventurous genre by creating a work full of visual energy and thought-provoking complexity. He depicts a corner of his studio, dominated by a plaster cast of Cupid standing on a table strewn with apples and onions. The floor beyond rises up, as does the row of painted canvases leaning against the wall. The space of the room is distorted, bringing the various objects into unexpected relationships with one another. Cézanne, for example, blurs the distinction between the 'real' apples, onions and blue cloth on the table in the foreground, and the propped canvas depicting similar objects on the left-hand side. It is as if this still-life painting on the floor has poured its contents into the room. In the top right-hand corner there is another painting within a painting, in this case of a different plaster-cast sculpture. By challenging our perception in this still life, Cézanne draws attention to the act of painting itself and to the ways in which we comprehend reality.

Paul Cézanne (1839–1906)
Apples, Bottle and Chairback, around 1904–06

Graphite and watercolour on wove paper, 46.2 × 60.4 cm
Samuel Courtauld bequest, 1948

In his studio in the hills north of Aix-en-Provence, Paul Cézanne produced an important group of still-life watercolours, of which this work is among the most magnificent. Remarkable for their freedom, imagination and sense of movement, and generally made on a large scale, in these late watercolours the artist pushed the boundaries of the medium. Rather than attempting an objective reproduction of nature, the artist sought to convey his personal vision of it.

This watercolour is a technical tour de force of looping, zigzagging pencil marks and brushstrokes combined to form an image that appears effortless. Cézanne laid out the composition in graphite before developing it with multi-layered applications of translucent and opaque washes. This skilful dialogue between graphite line and primary colours, as well as the luminosity of the bare paper, create an evocative effect that distances these objects from reality and moves them into the realm of pure imagination.

Georges Seurat (1859–1891)
The Bridge at Courbevoie, around 1886–87

Oil paint on canvas, 46.4 × 55.3 cm
Samuel Courtauld bequest, 1948

Although he died aged only 31, Georges Seurat was one of the great innovators of nineteenth-century French painting. He painted this view of the river Seine using a technique he had recently developed, called pointillism. It entailed placing dots of colour side-by-side to create an image, instead of mixing pigment on a palette. New optical theories at the time suggested that this made the painted surface more vibrant. Seurat applied this method to create harmonies of light and colour and the silvery effect of sunlight filtered through clouds.

The overall mood in this painting is one of melancholy and quiet. The stillness is emphasised by the isolated figures on the bank, as well as the vertical pattern of the trees and boat masts. The factory chimney in the background is a reminder that the riverside town of Courbevoie was rapidly becoming an industrial suburb of Paris.

Georges Seurat (1859–1891)
Young Woman Powdering Herself, around 1888–90

Oil paint on canvas, 95.5 × 79.5 cm
Samuel Courtauld gift, 1932

Counted among the seven major compositions Georges Seurat produced in his short career, this imposing work is the artist's only significant portrait. It depicts his partner, Madeleine Knobloch (1868–1903), applying make-up. She is seated at a small table whose cramped surface holds a delicate stand with a mirror and two perfume bottles. The theme of nature and artifice, represented by the use of cosmetics, is echoed in Seurat's distinctive technique, called pointillism. He applied a 'skin' of coloured dots to the surface of this work to animate it and create volume. Following optical theories that were being formulated at the time, he placed opposing colours – orange and blue, pink and green – next to each other for greater contrast.

In the frame above the sitter's head was once a mirror showing the reflection of Seurat at his easel. After it was ridiculed by a friend, Seurat replaced it with a vase of flowers, painting over his only known self-portrait.

Georges Seurat (1859–1891)

Nude, around 1879–81

Black Conté crayon over a preliminary drawing
of stumped graphite on laid paper, 63.2 × 48.3 cm
Samuel Courtauld bequest, 1948

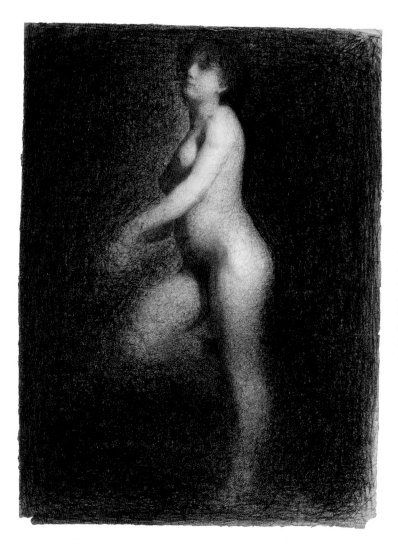

Probably executed during a life-drawing class, this early work shows Georges Seurat developing his distinctive drawing style. The figure, whose pose suggests she is leaning on a chair, emerges from the network of vigorous crayon marks that have been built up to form a subtle contrast between light and dark. To achieve the rich blacks, Seurat used a coarsely textured paper that caught the oily Conté crayon as it was dragged across the surface. He avoided harsh outlines, instead shaping the volume of the figure from masses of light and shadow. Subtle gradations of tone have been achieved through stumping, a technique whereby a roll of paper or leather is rubbed on the surface to blend certain areas. It is the extraordinary atmosphere of this drawing, however, that gives this work its power, with the stillness of the figure captured through dense layers of sinuous lines that almost pulsate with energy.

Edgar Degas (1834–1917)
After the Bath – Woman Drying Herself, around 1895

Charcoal and pastel on tracing paper laid down on cardboard,
67.7 × 57.8 cm
Samuel Courtauld gift, 1932

This lavish, large-scale pastel depicts a naked woman, her arm raised as she dries herself. Such intimate scenes increasingly occupied Edgar Degas in the later decades of his career. In these close-up views of faceless, naked bodies posed in undistinguished contemporary interiors, the artist aspired to represent a new type of modern female nude.

As is typical of his pastels, the medium is applied in distinct layers, with very little blending, over a charcoal underdrawing. Degas favoured tracing paper as it allowed him to incorporate earlier studies into his drawings. However, because pastel does not adhere easily to its smooth surface, he needed to use a fixative to secure each successive layer and prevent smudging. This method, unique to Degas, creates marvellous drifts of colour and unusual graphic rhythms, blurring the boundary between drawing and painting.

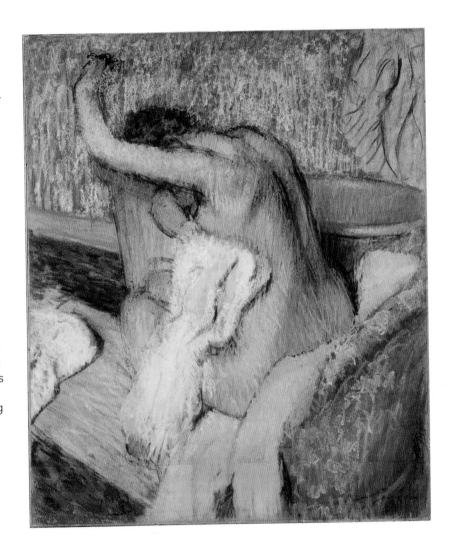

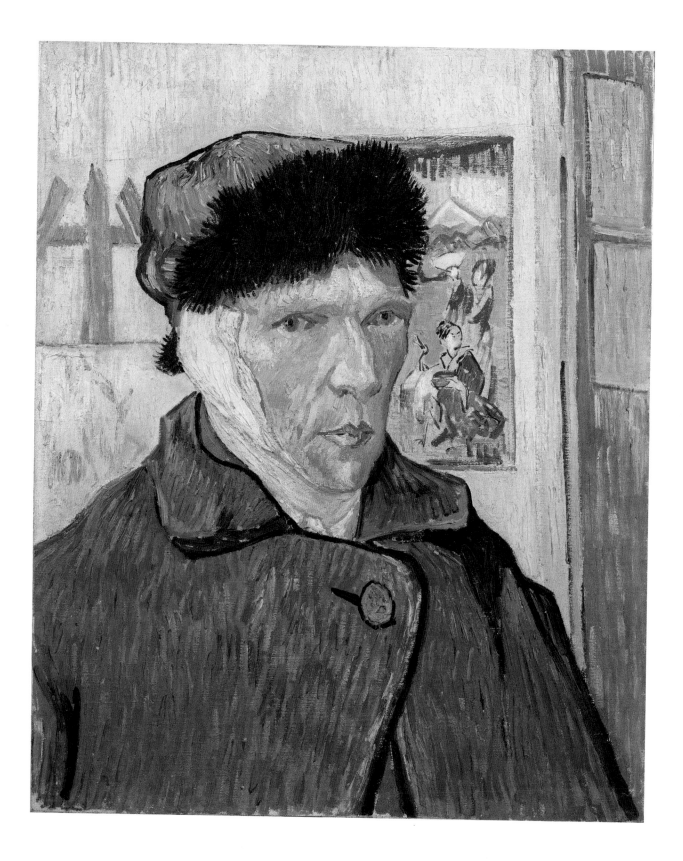

Vincent van Gogh (1853–1890)
Self-Portrait with Bandaged Ear, 1889

Oil paint on canvas, 60.5 × 50 cm
Samuel Courtauld bequest, 1948

This famous self-portrait by Vincent van Gogh expresses his artistic power and personal struggles. Van Gogh painted it in January 1889, a week after leaving hospital. He had received treatment there after cutting off most of his left ear (shown here as the bandaged right ear because he painted himself using a mirror). This self-mutilation was a desperate act committed a few weeks earlier, following a heated argument with his fellow painter Paul Gauguin, who had come to stay with him in Arles, in the south of France. He returned home from hospital to find Gauguin gone and with him, Van Gogh's dream of setting up a 'studio of the south', where like-minded artists could share ideas and work side by side.

The fur cap Van Gogh wears in this painting is a reminder of the harsh working conditions he faced in January 1889: the hat was a recent purchase to secure his thick bandage in place and to ward off the winter cold. This self-portrait is thus a powerful testament to Van Gogh's determination to continue painting. It is reinforced by the objects behind him, which take on a symbolic meaning: a canvas on an easel, just begun, and a Japanese print, an important source of inspiration. Above all, it is Van Gogh's bold handling of brushwork and colour that declare his ambition as a painter.

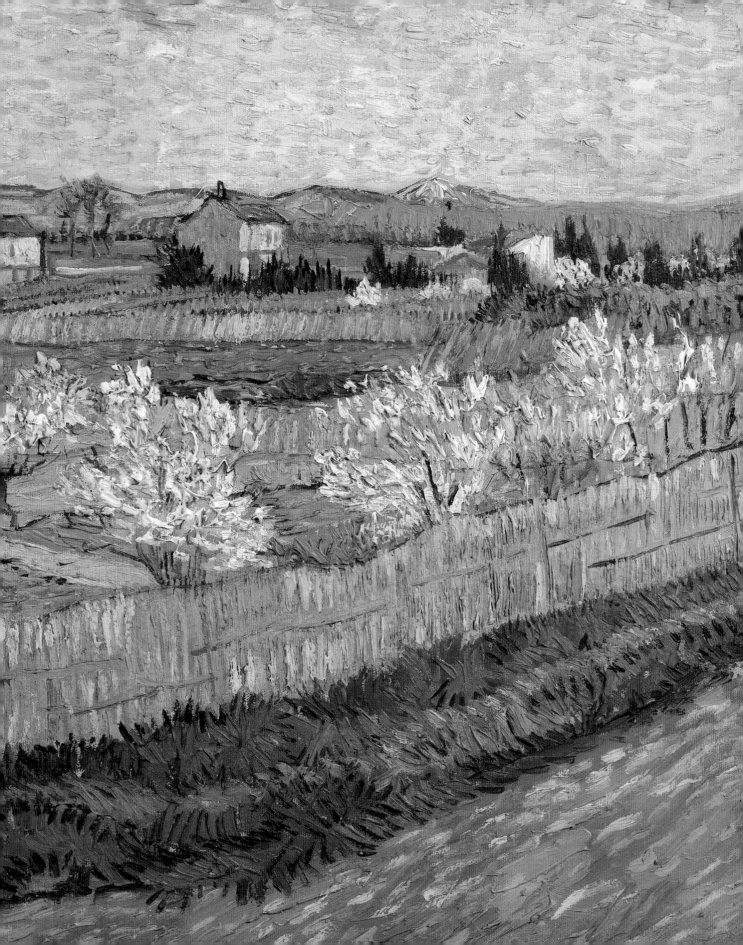

Vincent van Gogh (1853–1890)
Peach Trees in Blossom, 1889

Oil paint on canvas, 65 × 81 cm
Samuel Courtauld gift, 1932

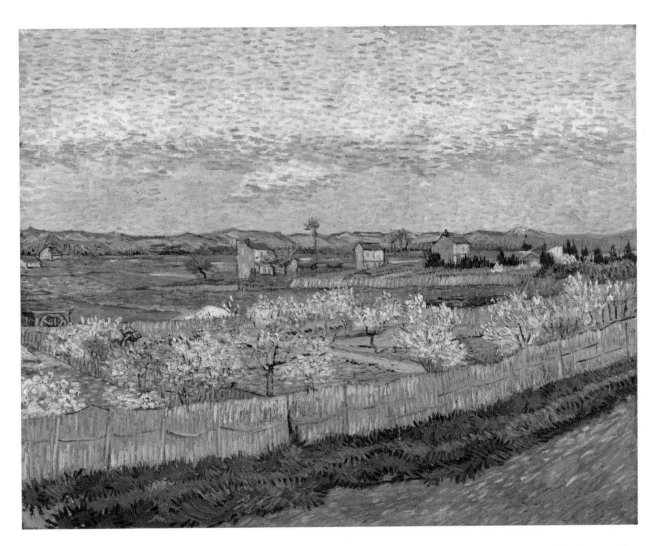

Vincent van Gogh captured this view of the plain of La Crau outside Arles in early spring 1889. It marked his return to painting outdoors following a mental breakdown a few months earlier (see pp. 100–01). He wrote to his brother, Theo, that the peach blossoms and the distant snow-capped mountain reminded him of the cherry trees and Mount Fuji in the Japanese prints he collected and greatly admired. The idea that the landscapes of southern France might resemble those of Japan had spurred Van Gogh to move there in 1888, hoping that the Provençal light and landscape would inspire his art.

During his stay in Arles, Paul Gauguin had encouraged Van Gogh to work from the imagination; here, Van Gogh commits to working from nature instead. He rendered the textures of the pebble-strewn road, wooden fence, grasses and blossoms with an extraordinary variety of brushmarks.

Paul Gauguin (1848–1903)

Nevermore, 1897

Oil paint on canvas, 60.5 × 116 cm
Samuel Courtauld gift, 1932

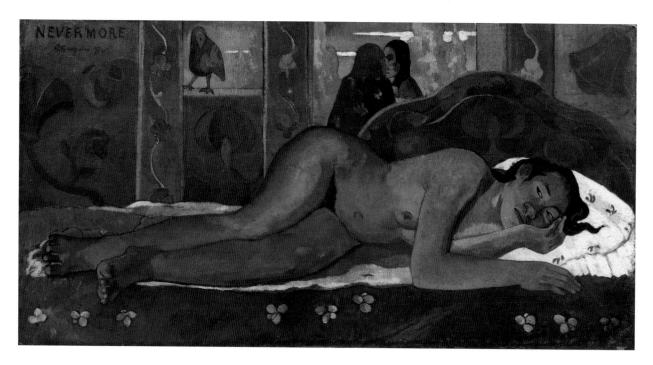

Paul Gauguin painted *Nevermore* in February 1897, during his second and final stay in Tahiti, an island in the southern Pacific colonised by France. Intended for a white European male audience, the sensual reclining nude belongs to a long Western artistic tradition. To this familiar theme, however, Gauguin added a sense of exoticism, writing to a friend that his nude is meant to suggest 'a certain barbarian long-lost luxury'.

This disconcerting painting combines beauty and eroticism with a strong feeling of unease. The young woman is not at rest, but anxiously aware of the bird and the strange beings behind her, who might be evil spirits. For modern viewers, the youth of the nude figure, sometimes identified as Paul Gauguin's 15-year-old partner Pahura, is its most unsettling aspect.

The painting's title associates the bird on the ledge with Edgar Allan Poe's poem *The Raven* (first published in 1845, translated into French in 1875). In it, a poet, driven mad by the death of his lover, hears a raven endlessly repeating 'nevermore'. This sense of loss has sometimes been seen as alluding to Gauguin's disillusionment at the destruction of Tahitian culture by the French colonial administration and Church missionaries. Instead of the unspoilt paradise he had imagined, he found a society compromised and corrupted by decades of colonialism. Yet, this did not prevent him from taking advantage of his position as a European coloniser. Pahura was one of several teenagers that he took on as 'wives'. The widespread racist fantasy of Tahitian girls as sexually precocious led to their unabashed exploitation.

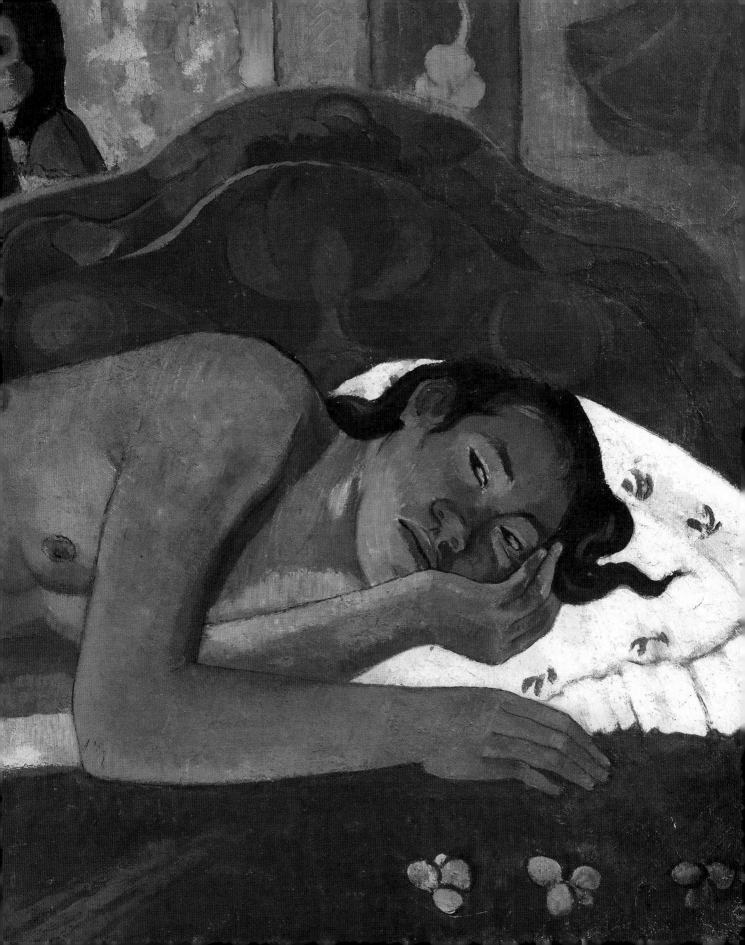

Paul Gauguin (1848–1903)
Te Rerioa (The Dream), 1897

Oil paint on canvas, 95.1 × 130.2 cm
Samuel Courtauld gift, 1932

Paul Gauguin painted this striking work a few years after settling in Tahiti, a French colony in the southern Pacific, and only weeks after *Nevermore* (see pp. 104–05). The two canvases travelled on the same ship to France, where they were sold by Gauguin's art dealer. The artist reported that he had produced *Te Rerioa* in less than ten days, taking advantage of a delay in the ship's departure. However, the carefully constructed composition, its solemnity and balance, belie a completely spontaneous undertaking. *Te Rerioa* was in fact the last in a series of ambitious canvases painted by Gauguin in the preceding months.

Te Rerioa depicts two women watching over a sleeping child in a room decorated with elaborate wood reliefs. The symbolic meaning of the carvings' subject matter – an embracing couple, hybrid creatures and vegetation – has been the subject of much speculation but like the women's relationship,

Gauguin has left it deliberately ambiguous. He titled the painting *Te Rerioa* (meaning 'dream' or 'nightmare' in Tahitian), writing to a friend, 'everything is dream in this canvas, whether it be the child, the mother, the horseman on the road, or the dream of the painter.'

Gauguin conferred Tahitian titles to his paintings from the beginning of his first stay in French Polynesia, in 1891. He not only noted them in his ledger and explained them in his correspondence, but he also inscribed them on the surface of the paintings themselves, asserting his proximity to Tahitian culture. His exoticising representation of Polynesia in works such as *Te Rerioa* was intended to appeal to a white European audience, perpetuating the fantasy of a natural paradise on the other side of the world.

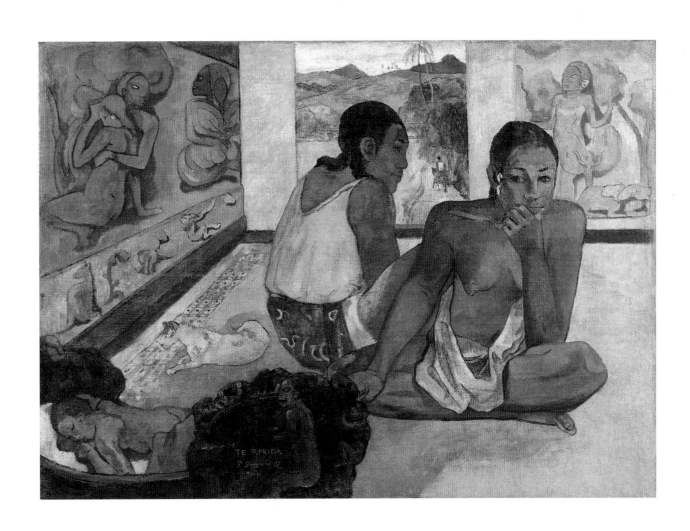

Paul Gauguin (1848–1903)
Avant et après (Before and After), 1903

Manuscript in pen and black ink, containing pen and ink drawings,
monotypes and other prints, 29.6 × 21.7 × 2.3 cm
Accepted by HM Government in lieu of Inheritance Tax
and allocated to the Samuel Courtauld Trust, 2020

Although little published during his lifetime, Paul Gauguin was a prolific writer whose literary output is intimately entwined with his art. *Avant et après (Before and After)*, his final manuscript, was completed on Hiva Oa, part of the Marquesas Islands, during the last months of his life. Ravaged by the effects of syphilis, the artist was aware of his mortality and *Avant et après* served as final testament of sorts.

In the 213 handwritten pages of this part-memoir, part-manifesto, Gauguin muses on his own art and records anecdotes of his friendships and conflicts with other artists and writers. He also launches stinging attacks on the critics who misunderstood him and on bourgeois morality and hypocrisy – a lifelong obsession. Gauguin set down blistering tirades against the French colonial and church authorities in Polynesia, yet the text is peppered with examples of his own racism and misogyny.

One of the most celebrated passages is the story of Gauguin's brief, but tumultuous, working relationship with Vincent van Gogh in Arles (see pp. 100–01). *Avant et après* offers the only eyewitness account of the incident in which Van Gogh severed his own ear following a violent quarrel – albeit a heavily embroidered one that casts

Gauguin in a more favourable light than he probably deserved.

The relationship between word and image was a central concern of Gauguin's art and writing, and *Avant et après* is typical in combining both. He designed the elaborate cover and the manuscript is interspersed with numerous pen and ink drawings, as well as many monotypes, depicting the landscapes and people of the Marquesas Islands. Gauguin devoted himself to the monotype in his final years, a medium that blurred the distinction between drawing and printmaking, remaining among his most distinctive creations.

Henri de Toulouse-Lautrec (1864–1901)

Jane Avril in the Entrance to the Moulin Rouge, around 1892

Oil paint and pastel on board, 102 × 55.1 cm
Samuel Courtauld gift, 1932

Jane Avril (the stage name of Jeanne Beaudon, 1868–1943) was a star dancer at the famous Parisian cabaret Le Moulin Rouge (The Red Windmill). There, she met Henri de Toulouse-Lautrec, who designed the venue's well-known posters, some of which featured her as a flamboyant attraction. By contrast, this portrait stands out for its subdued quality. She is not shown on stage but arriving at, or possibly leaving, the cabaret, bundled in a fur-collared coat. The lit interior and the large wheel of a carriage are visible in the background. The painting's unusual narrow format and the application of paint and pastel in slashing vertical strokes accentuate Avril's long face and gaunt figure. Although only in her early twenties, she looks older as her pallor is accentuated by the artificial yellow light. This portrait's psychological acuity and its emphasis on Avril as a private individual attest to the close friendship between her and Toulouse-Lautrec. Rather than a celebrated stage presence, he presents her as a complex and introspective woman.

Henri de Toulouse-Lautrec (1864–1901)

The Jockey, 1899

Lithograph, 51.6 × 36.3 cm (image)
Samuel Courtauld gift, 1935

Created late in Henri de Toulouse-Lautrec's career, *The Jockey* originated as part of a commissioned series of lithographs on equestrian subjects, long a source of fascination for the artist. Seemingly fused into single beings, two jockeys and their racehorses gallop along the racetrack in a display of remarkable dynamism. The sophisticated tonal effects, which mimic the qualities of graphite, chalk and charcoal, showcase Toulouse-Lautrec's inventive approach to the technique of lithography. The influence of Japanese prints is apparent in the composition's strong diagonal thrust, the boldly silhouetted shapes, and the expressive distortion of the horses and jockeys. The high viewpoint and the abrupt cropping of the horse in the foreground give the impression that the horse and its rider are suspended in space.

Toulouse-Lautrec's deteriorating health meant the series was incomplete at his death in 1901. *The Jockey* was printed in both colour and black and white. Only ten black-and-white impressions of the first state were printed, making this impression exceptionally rare.

The Courtauld Today

Alixe Bovey
Dean and Deputy Director

When the Courtauld Institute of Art was established in 1932, the history of art was in its infancy as an academic subject in the English-speaking world. The Courtauld's founders recognised the intellectual potential of the subject, and also observed a need for people with solid, rigorous training in the professions associated with the visual arts. Over the 90 years since its foundation, the academic activity of The Courtauld has grown in ways that have shaped, and been shaped by, an ambition that art history should be an expansive, outward-looking and globally engaged subject.

Today, The Courtauld's faculty consists of around 35 academics who belong to two departments – History of Art and Conservation – and there is an impressive international cohort of more than 500 students. Our 8,000 alumni form a global network, living and working in over 80 countries. Many of the world's major museums and galleries have been led and curated by Courtauld graduates, including the National Gallery, National Portrait Gallery and Tate Modern in London, and further afield the Metropolitan Museum of Art (USA), Istanbul Modern Art Museum (Turkey) and Christchurch Art Gallery Te Puna o Waiwhetū (New Zealand). Graduates include pioneering professionals within the fields of art history and conservation, including entrepreneurs, lawyers, publishers, journalists, politicians and educators. Whether working in the arts or other fields, alumni use the skills that they learned at The Courtauld to analyse, challenge and change the world around them.

The History of Art department possesses expertise spanning from late Antiquity to the present and has established strengths in Europe, North America, the Middle East and Asia. Undergraduate students have the opportunity to develop a broad understanding of the subject and its methods, and also to focus on areas of particular interest to them.

[1] A class on Early Modern Chinese art at the British Museum

Those choosing to study an MA in the History of Art can draw on more than 20 specialist options that reflect the research expertise of the faculty, with the Curating the Art Museum MA programme attracting students who aspire to a range of careers in museums and galleries, thus developing a historical understanding alongside cutting-edge curatorial skills.

As with any university, we teach in classrooms and lecture theatres, but as much as possible we take our students to museums, galleries (including, of course, our own) and heritage sites in London and beyond [1]. Students are encouraged to think about art from a variety of perspectives – those of makers, patrons, collectors and viewers – and to consider the life cycle of the work of art, from its conception, materials and production, and reception, to how it has changed over time [2].

[2] Professor Sussan Babaie and her students

Students consider works of art relating to every facet of human endeavour – from grand themes such as religion, politics, science and technology, and nature, to intimate conditions, such as love, grief, lust and hope.

The preservation and restoration of works of art are the focus of our Department of Conservation, one of the world's leading centres for the research and education in the care and conservation of painted surfaces – especially paintings on canvas, wood and walls. This activity is fundamentally interdisciplinary, drawing on the sciences, art history, an understanding of artists' materials and techniques, and hands-on skills. We offer programmes for those wanting to specialise in the conservation of wall paintings, and for the conservation of easel paintings [3]. Students training to be easel-painting conservators have

hands-on experience examining and conserving works of art in public and private collections, thus developing the essential skills required to care for paintings. Our wall-paintings conservation programme takes faculty and students to sites across the United Kingdom and around the world, from the Caucasus to India, China and Bhutan.

Since our foundation, research has been at the core of The Courtauld's academic enterprise: Courtauld researchers are engaged in the discovery of historical evidence, intellectual themes, artistic practices, and insights into the making and meaning of works of art [4]. The Courtauld's Research Forum is the main hub for sharing advanced research in art history with students, researchers and a wider public, through seminars, lectures, workshops and the biannual research festival ResFest. ResFest is an opportunity

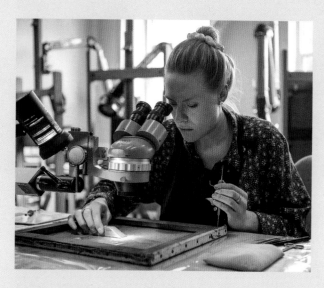

[3] A student at work, examining
a painting in the Department of
Conservation

[4] A tutorial in the Gallery's Prints and
Drawings Study Room

for us to celebrate art historical research with talks, workshops, music and poetry, in the convivial surroundings of our own campuses, as well as in partnership with the museums around the United Kingdom. A wealth of material from the Research Forum is available online [5].

The Courtauld believes that art history is everybody's history and is committed to sharing research and teaching with all those with an interest in human creativity. Through Young People's programmes, we are able to bring Courtauld education to primary and secondary school children all over the United Kingdom; activities at Somerset House welcome groups of students into our galleries and classrooms, and bring workshops and materials to schools all over the country. There is also a Summer University, which welcomes students considering studying

art history at a degree level, for an intensive week-long introduction to the way that the subject is studied at university. We are building pathways into the history of art, and enabling a richer understanding of art as it relates to other subjects for new audiences. Other programmes offer study opportunities for those wanting to attain qualifications and those keen to study for pleasure and personal interest. We offer an incredibly rich programme of short courses dedicated to particular subjects and themes, and led by experts. These courses take the form of week-long spring and summer schools, evening lecture series, study days and trips.

Supporting all of our research and teaching is The Courtauld's library and photographic collections. Our library is one of the finest of its kind in the world, and alongside it are photographic

[5] Preparing to welcome guests to our
art history research festival, ResFest

collections that record works of art and architecture,
in all media and from around the world. An
invaluable resource for researchers, these
collections document works of art in public and
private collections. Many of the images are
themselves notable works of art or of historical
significance. These photographic collections are
being unlocked for public benefit through an
ambitious digitisation programme, supported by
more than a thousand volunteers.

As we approach The Courtauld's 100th
anniversary in 2032, we look forward to the next
century and will remain as committed as ever to our
core foundational aim: to make the visual arts
accessible to everyone, through our Gallery,
research and education.

Amedeo Modigliani (1884–1920)
Nude, around 1916

Oil paint on canvas, 92.4 × 59.8 cm
Samuel Courtauld gift, 1932

This striking female nude is one of several painted by Amedeo Modigliani between 1916 and 1917. Beyond the reclining figure's apparent gracefulness and tranquillity, the painting presents a radical reworking of the conventions of figure painting, which still retains some of its original provocation today. Modigliani incorporated stylistic elements taken from cultures outside Europe with the Western tradition of idealised female nudes. The woman's elongated head, for example, relates to the Egyptian, African and Oceanic sculptures he had studied at Paris's ethnographic museum of the Trocadéro. Furthermore, the artist's rough handling of paint differs from the highly finished, smoothed surfaces found in most Salon nudes of the period. Her flushed face, scratched-out strands of hair and the rawness of brushwork present a sexualised form of beauty that went against conventional standards. The depiction of pubic hair was also shocking at the time. Police even closed a 1917 exhibition of Modigliani's nudes at the Berthe Weill gallery in Paris on the grounds of indecency.

Henri Matisse (1869–1954)

Seated Woman, 1919

Graphite on wove paper, 35.5 × 25.4 cm
Samuel Courtauld gift, 1935

This drawing is a study for a painting that Henri Matisse executed in the summer of 1919. The sitter is the nineteen-year-old Antoinette Arnoux, who modelled for the artist for two years. During this time, he created a substantial body of work featuring Arnoux, who played a key role in the artist's evolving draughtsmanship.

Here, the focus is on her costume. After visiting Morocco several years earlier, Matisse became fascinated with North African dress that he would later transform, in concert with his models, into an Orientalist fantasy. Arnoux sports a loosely tied headscarf, a sleeveless vest and a transparent blouse that skims her bare breasts. Using precise lines and disciplined hatching, Matisse has created a drawing of adeptly balanced contrasts. Framed by the edges of the chair, Arnoux's frontal pose and her direct gaze combine with her soft contours and the sinuous lines of her revealing clothes to form an image of unnerving sensuality.

Vanessa Bell (1879–1961)
A Conversation, 1913–16

Oil paint on canvas, 86.6 × 81 cm
Gift of the Roger Fry Trustees, 1935

Vanessa Bell was one of the most innovative modern painters in Britain before and during the First World War. *A Conversation* is one of her major achievements, which she worked on at various points over several years. Bell used bold colours and simplified forms to depict three women in deep discussion. The arrangement of the figures and the close grouping of the women's heads give the gathering a sense of drama and a conspiratorial air. The painting's scale and strong visual impact suggests the conversation is of great significance, although we are left to imagine what is being discussed. Bell was a major figure among the avant-garde artists and writers known as the Bloomsbury Group. Perhaps with this work she was paying tribute to the values of friendship and enlightened debate that characterised this group.

Roger Fry (1866–1934)
Portrait of Nina Hamnett, 1917

Oil paint on canvas, 82 × 61 cm
Gift of the Roger Fry Trustees, 1935

The subject of this portrait is the artist Nina Hamnett (1890–1956) who lived and painted in the bohemian art worlds of London and Paris. She worked with the artists known as the Bloomsbury Group at the Omega Workshops, which was founded in London by Roger Fry in 1913. In this portrait, Fry accentuates particular forms, such as the long, elegant line of Hamnett's arm and hand. He also sharply delineates her bobbed haircut and the creases and contours of her plain working clothes, features that would have marked her as a strikingly modern woman to contemporary viewers.

Roger Fry (1866–1934)

for the Omega Workshops Ltd (1913–1919)

Dinner or dessert plate, 1914–18

Made at Carter & Co, Poole, Dorset
Earthenware, black glaze, 25 cm (diam.)
Gift of the Roger Fry Trustees, 1935

Coffee pot, 1918

Made at Carter & Co, Poole, Dorset
Earthenware, white tin glaze, 17.8 cm (h)
Gift of the Roger Fry Trustees, 1935

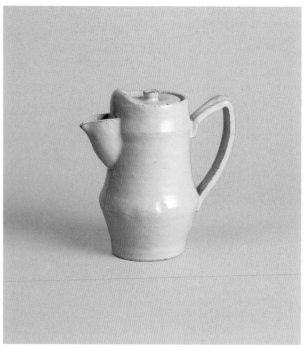

The Omega Workshops sold homewares designed and made by artists. It was established in London by Roger Fry, in association with younger artists in the Bloomsbury Group, Vanessa Bell and Duncan Grant. The Omega sought to bring avant-garde art into British homes and provide regular paid work for struggling artists. Opened on the eve of the First World War, it soon became a centre for pacifist resistance, holding concerts, publishing books and celebrating international artistic collaboration.

One of the Omega's specialities was ceramics. At first, artists painted directly onto commercially manufactured plates. Soon, Fry learned to make his own ceramics, and became passionate about producing strikingly simple white and black tableware. Monochrome dishes were insistently modern – visually offsetting the boldly colourful Omega patterns seen on furniture and textiles.

Duncan Grant (1885–1978)
for the Omega Workshops Ltd (1913–1919)
Screen with lily pond design, 1913–14

Oil paint on wood, 181.6 × 242.4 cm
Gift of Fedora Stancioff in memory of Lady Muir
of Blair Drummond, 1961

The Bloomsbury artist Duncan Grant is said to have based this design on a goldfish pond at Roger Fry's house in Surrey. The fluid forms create an abstract pattern that is loosely organic, with unexpected pops of bright colour. The effect seems to recall camouflage patterns of the First World War.

Painted tables, chairs and screens were sold at the Omega Workshops – these were manufactured by commercial firms, but decorated by its artists. This pattern recurs in a few tables also attributed to Grant, as well as small boxes, and at least one other screen with this design is known.

Helen Saunders (1885–1963)

Vorticist Composition with Figures, Black and White, around 1915

Graphite and black ink and collage on wove paper, 25.4 × 17.8 cm
Purchased by the Samuel Courtauld Trust, 2016

Among the first British artists to work in a non-figurative style, Helen Saunders was one of only two women members of the Vorticists, a radical but short-lived London modern art movement (1914–15) influenced by Cubism. This bold, hard-edged composition, with its sharp geometric forms and dramatic monochrome contrasts, reflects Vorticism's decisive break with the art of the past. The composition leads the viewer towards the prominent circle in the upper centre, which can read as a giant eye or sun – this was drawn on a separate piece of paper then glued down. The forms in the lower half of the drawing suggest human figures at the mercy of a colossal machine, undoubtedly reflecting the events of the First World War.

Despite her long career, much of Saunders's work has been lost. Only in recent years has this groundbreaking artist been rediscovered and appreciated. The Courtauld holds an outstanding group of works by Saunders, the majority of which were presented by Brigid Peppin in 2016.

Wassily Kandinsky (1866–1944)

Untitled, 1916

Brush and black ink on wove paper, 15.8 × 23.4 cm
Gift by Linda Karshan, in memory of her husband Howard Karshan, 2020

Over the first year of his exile in Moscow during the First World War, Wassily Kandinsky focused entirely on drawing. This coincided with a period of transition in Kandinsky's work, moving from the last vestiges of figuration toward pure abstraction, as demonstrated in this drawing.

The drawing balances gestural vigour and control. The composition seems to spring from the upper right corner of the sheet and spiral clockwise, sweeping the sprays of eyelash-like parallel hatching into a whirling dance. The rhythmic, musical quality of the line is common to much of Kandinsky's contemporary work. Although it appears swiftly drawn, the three different applications of ink, which would have had to dry individually, reveal that he planned and executed the drawing with care. Kandinsky considered his work the visual expression of a spiritual state. This drawing seems to bristle with a dark energy, reflecting the anxieties he must have been experiencing at the time.

Oskar Kokoschka (1886–1980)

The Myth of Prometheus, triptych: **Hades and Persephone** (left),
The Apocalypse (centre), **Prometheus** (right), 1950

Oil paint and mixed media on canvas, 239 × 234 cm (left and right canvases),
239 × 349 cm (centre canvas)
Princes Gate bequest, 1978

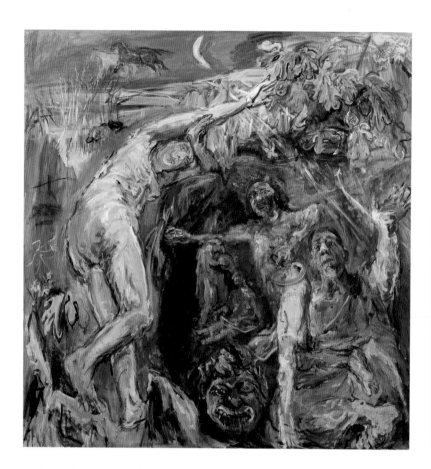

Oskar Kokoschka was commissioned to paint this large triptych in 1950 by Count Antoine Seilern for the entrance-hall ceiling of his London house, 56 Princes Gate, South Kensington (pp. 13–14). Kokoschka spent over six months working on the canvases on easels in a room at the house. On 15 July he wrote, 'I put the last brush-stroke (I feel like saying axe-stroke) to my ceiling painting yesterday … This is perhaps my last big painting, and perhaps it's my best'. The commission was Kokoschka's opportunity to produce a monumental work following the tradition of Baroque painters such as Peter Paul Rubens and Giovanni Battista Tiepolo, whom he admired and whose work formed a central part of Seilern's art collection.

Kokoschka reworked biblical and mythological stories in the triptych to express his fears for humanity following the Second World War and the dawn of the Cold War era. The central canvas shows the Four

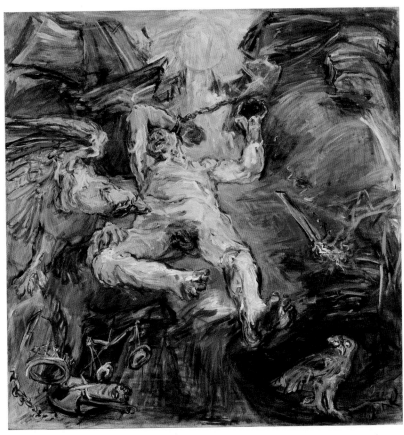

Horsemen of the Apocalypse charging towards unsuspecting figures on the hillside opposite. This vision of impending destruction is flanked on the right by a canvas depicting Prometheus in chains, as punished by Zeus for stealing the fire of divine wisdom. For Kokoschka, Prometheus symbolised humanity's deadly desire for power beyond its control. The left-hand canvas shows the earth goddess Demeter receiving her daughter

Persephone as she is freed from the clutches of Hades, god of the underworld (represented as the artist's self-portrait). This scene offers the hope of freedom and regeneration, which Kokoschka maintained was only possible by returning to compassionate maternal values, depicted here as the joyful reunion of mother and daughter.

Louis Soutter (1871–1942)
Frapper? (Beat?), around 1937–42

Black ink on wove paper, 51 × 68 cm
Gift by Linda Karshan, in memory of her husband, Howard Karshan, 2020

The musician and artist Louis Soutter spent the last 20 years of his life in a hospice for elderly men in his native Switzerland. The hospice's regulations prompted Soutter to abandon his violin in favour of drawing and painting. In 1937, arthritis and failing eyesight forced him to give up conventional drawing. The artist transformed this physical limitation and the paucity of materials available into a virtue. He turned to drawing with a brush and also used his fingers dipped in ink, working directly onto large sheets of paper. He tapped into an archaic form of mark making, a prehistoric tradition of using fingers and hands to produce images. *Frapper?*, populated by a frieze of wild figures who seem to be dancing to frenetic music or fleeing danger (as suggested by the title), is an outstanding example of the artist's work at the time.

Georg Baselitz (b. 1938)
Ohne Titel (Tierstück) (Untitled [Animal Piece]), 1965

Ink on paper, 64.8 × 49.9 cm
Gift by Linda Karshan, in memory of her husband, Howard Karshan, 2020

In the early 1960s, Georg Baselitz emerged as a forceful and unconventional figurative artist, committed to creating work that shocked his viewers, and expressed the trauma and rawness of the post-Second World War era in Germany. The artist's morbid fascination with dismembered bodies pervaded his work at the time and this large drawing is a striking example of the nightmarish images of decay that he produced, partly as a protest against artistic and political conventions. At first sight, this work reads as a lumpy pyramidal heap of indistinct bulbous forms set amid a barren landscape and crowned by a radiating sky. Closer looking reveals two amorphous figures bending forwards as if in pain, defeated or ashamed. Armless, their faces are larva-like and their bodies seem swollen and mutilated. These eerie creatures connect this drawing to his *Animal Pieces* series, which was partly inspired by the concept of anamorphosis, the process of depicting an image in a distorted or monstrous way.

Frank Auerbach (born 1931)
Rebuilding the Empire Cinema, Leicester Square, 1962

Oil paint on board, 152.5 × 152.5 cm
Accepted by HM Government in Lieu of Inheritance Tax
and allocated to The Samuel Courtauld Trust, 2015

Frank Auerbach established his reputation as a leading modern painter in post-war London. One of his main subjects during that period was the bomb-scarred landscape of London and especially the numerous building sites that emerged across the city as reconstruction work got underway. Auerbach made repeated visits to different building sites, dodging workmen to find a spot to make swift sketches of the construction activity. Back in his studio, these sketches were the basis of his paintings, each of which typically took many months to produce, the paint building up into an encrusted and richly textured surface.

Auerbach made thirteen major building-site paintings between 1952 and 1962: *Rebuilding the Empire Cinema, Leicester Square* was the last of the series. The artist recalled passing the outside of the cinema and looking in to discover a scene of frenetic activity, which he sketched immediately, 'I did the drawing with a very considerable feeling of urgency

… I knew what I saw there would no longer be there perhaps a fortnight later. The composition in a way was a gift … you looked through and saw something marvellous'.

His sketch of the scene resulted in this dramatic painting. The thick red lines that structure the composition are beams or scaffolding spanning a gaping chasm in the foreground. As viewers, we stand at the very edge of this dark void, the confined space as a whole lit by a few patches of light towards the bottom and top of the picture. The result is a disorienting scene of partially constructed floor levels, jutting beams and extremes of light and dark. Auerbach's use of red throughout the work adds fiery intensity, as if we are witness to an almost hellish vision.

The painting was formerly in the collection of the artist Lucian Freud, who was a close friend of Auerbach and owned a significant number of his paintings.

Richard Long (born 1945)
A Line Made by Walking, 1967

Black and white photograph, mounted on board
and titled in red crayon and graphite, 37.5 × 32.4 cm (photograph)
Gift of the artist, 2009

This is a pivotal early work in Richard Long's career. At the time, he was studying sculpture at St Martin's School of Art in London. During a journey out of the city, Long stopped at a field in the open countryside and walked back and forth, trampling the grass to create a line. He photographed the result and titled this landscape work, *A Line Made by Walking*. It was a new way of making art beyond the confines of the studio and gallery. This work heralds Long's career producing landscape art, which has often been bound up with his experience of extended and arduous walking expeditions, which have taken him across the globe.

A LINE MADE BY WALKING

ENGLAND 1967

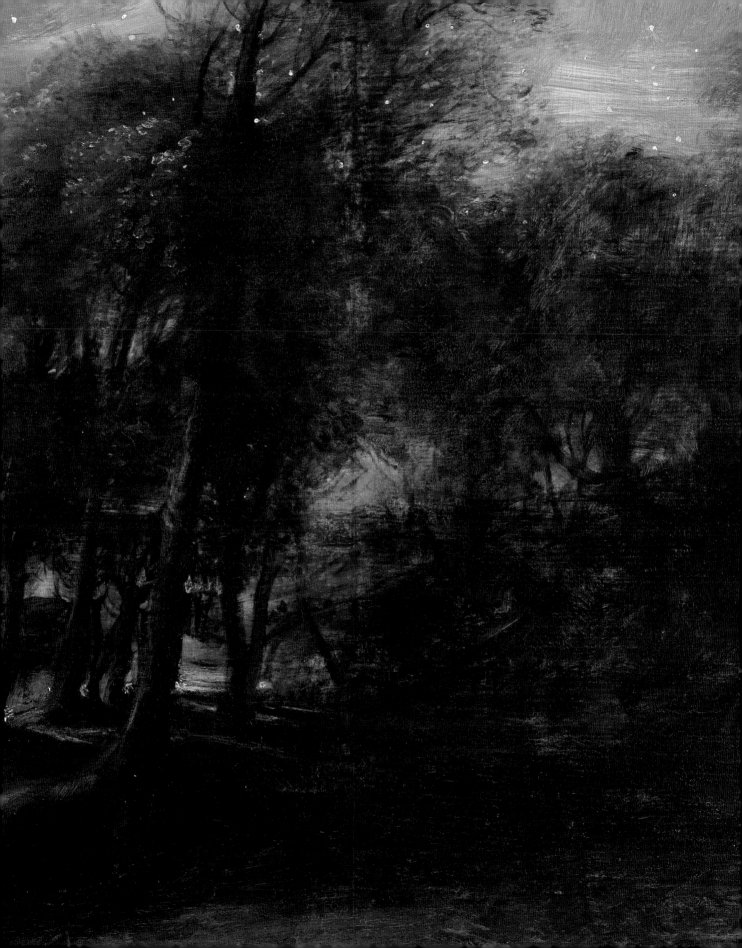

Index

Lucian Freud (1922–2011)

Blond Girl, 1985

Etching, 69 × 54.2 cm (image)
Gift of Frank Auerbach, 2012

From the 1980s onwards, Lucian Freud produced etchings of people who posed for him, either clothed or naked, in his studio. His unusual approach was to work directly on the etching plate with the model in front of him, rather than relying on preparatory drawings. In this major print, Freud concentrates intensively on depicting the woman's face and body. By leaving the setting blank, Freud gives a greater sense of the shape and mass of the woman's form, her position implying she is posed on a sofa or bed. This is one of several prints that Freud inscribed and presented to his close friend, the painter Frank Auerbach. After Freud's death, Auerbach gave these etchings to The Courtauld.

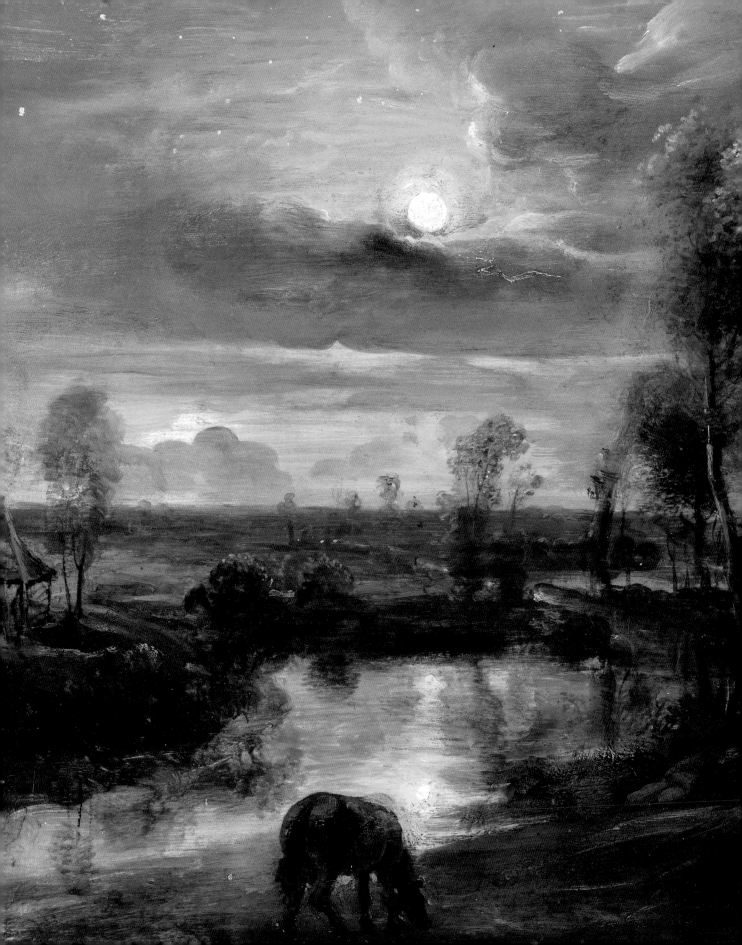

Picture Credits